American Dreams

Paintings and Decorative Arts
from the Warner Collection

David Park Curry
with
Elizabeth L. O'Leary
Susan Jensen Rawles

Virginia Museum of Fine Arts, Richmond

This book was published on the occasion of the exhibition
American Dreams: Paintings and Decorative Arts from the Warner Collection, September 20, 1997–January 25, 1998.

The book and exhibition were made possible, in part, by The Council of the Virginia Museum of Fine Arts; the Fabergé Ball Endowment; Mrs. George E. Allen, Jr.; Mrs. Betty Sams Christian; Mr. and Mrs. Alan S. Donnahoe; Mr. and Mrs. T. Fleetwood Garner; Mr. and Mrs. Bruce C. Gottwald; Mr. and Mrs. Floyd D. Gottwald, Jr.; Mr. and Mrs. John C. Kenny; Life of Virginia; and Coopers and Lybrand.

Library of Congress Cataloging-in-Publication Data
Curry, David Park
 American Dreams: paintings and decorative arts from the Warner Collection / David Park Curry with Elizabeth L. O'Leary, Susan Jensen Rawles.
 p. cm.
 Catalogue of an exhibition of American art held at the Virginia Museum of Fine Arts, Richmond, Va., Sept. 20, 1996–Jan. 25, 1997.
 Includes index.
 ISBN 0-917046-48-X
 1. Art, American—Exhibitions. 2. Warner, Jack (Jonathan)—Art collections—Exhibitions. 3. Art—Private collections—Alabama—Exhibitions. I. O'Leary, Elizabeth L. II. Rawles, Susan Jensen. III. Virginia Museum of Fine Arts. IV. Title.
 N6505.C88 1997 97-30069
 CIP

ISBN 0-917046-48-X

Printed in the United States of America

Produced by the Office of Publications, Virginia Museum of Fine Arts,
 2800 Grove Avenue, Richmond, VA 23221-2466 USA

Monica S. Rumsey, Editor-in-Chief
Rosalie West, Project Editor
Morgen Cheshire, Assistant Editor

Jean Kane, Graphic Designer
Composed by the designer on the Macintosh using QuarkXPress. Type set in New Caledonia.

Printed on acid-free 80 lb. Warren Lustro Dull text by Carter Printing Co., Richmond.

Front Cover: *Tanis*, 1915, by Daniel Garber (1880–1958), oil on canvas. **Back Cover:** *Progress (The Advance of Civilization)*, 1853, by Asher B. Durand (1796–1886), oil on canvas. **Page 80** (opposite inside back cover): *Pitcher (Vase-Shaped)*, 1828, by Tucker & Hulme, painted and gilded porcelain. The Warner Collection of Gulf States Paper Corporation.

Contents

Quality counts.

Foreword

Quality counts! The company motto for the Gulf States Paper Corporation is equally applicable to the collection of American art assembled under the company's aegis. We are honored to present selections from this collection at the Virginia Museum of Fine Arts, where admiration for quality and the love of things American are hallmarks. The present selection of paintings and decorative objects, one of the finest comprehensive collections of American art still in private hands, suggests the originality and care characteristic of a collection assembled with passion and knowledge. Committed collectors, such as Jack and Elizabeth Warner of Tuscaloosa, Alabama, are especially unusual, and we are grateful to them for sharing their achievements and their enthusiasm. Through the courtesy of the David Warner Foundation and the Gulf States Paper Corporation, of which Jack is now Retired Chairman and Chief Executive Officer, the Warners have unselfishly parted with a host of treasures for an extensive period, so that a large audience might have the rare opportunity of enjoying them here in Virginia.

The world of art can be remarkably "interwoven," and I am especially grateful to museum trustees Sydney and Frances Lewis—whose own collecting achievements are of fundamental significance for this institution—for their encouragement of this enterprise. Sydney Lewis and Jack Warner were classmates at Washington and Lee University, and we are pleased that strong school ties have helped bring the Warner collection here.

The Council of the Virginia Museum of Fine Arts is to be especially thanked for providing the necessary funds for this publication celebrating American Dreams. We are deeply grateful to the public-spirited donors who generously came forward to support this undertaking:

The Council of the Virginia Museum of Fine Arts
The Fabergé Ball Endowment
Mrs. George E. Allen, Jr.
Mrs. Betty Sams Christian
Mr. and Mrs. Alan S. Donnahoe
Mr. and Mrs. T. Fleetwood Garner
Mr. and Mrs. Bruce C. Gottwald
Mr. and Mrs. Floyd D. Gottwald, Jr.
Mr. and Mrs. John C. Kenny
Life of Virginia
Coopers and Lybrand

Special recognition is due to David Park Curry, whose eye and taste for American art contributed to a rich collaboration with the collectors in forming the exhibition and preparing this book.

Katharine C. Lee
Director
Virginia Museum of Fine Arts

Acknowledgments

Curators dream of meeting collectors who invite them into treasure-filled rooms and say, "Choose whatever you like." Well, sometimes you get what you want. Over the past few years I have had the pleasure of working with Jack and Elizabeth Warner, experiencing both the boundless warmth of their southern hospitality and the incredible range of painting, sculpture, and decorative arts that make up the Warner collection of the Gulf States Paper Corporation and the David Warner Foundation. I am deeply indebted to Jack and Elizabeth for letting us introduce some of these magnificent pieces to museum visitors here in the Commonwealth of Virginia.

Works of art are not the only treasures that surround the Warners. Their staff has been unstinting in its support of this undertaking. The tireless efforts of Charles Hillburn, Fine Arts Manager at the corporation, revealed skillful organization and unflappable common sense that kept our project on track from the very beginning. We would also like to thank Candace C. Grant, Lou Lombardy, Lee Andrews, and Dave Gardner, all of the Gulf States Paper Corporation, and Willie Cleveland, caretaker of the Mildred Warner House.

President and Mrs. Andrew Sorensen of the University of Alabama kindly gave us complete access to the beautifully refurbished rooms of the university's official mansion.

At the Virginia Museum of Fine Arts, it has been a special privilege to work with two insightful scholars, my research associate Dr. Elizabeth L. O'Leary and Susan Jensen Rawles. Their ideas significantly shaped not only this publication, but also the didactic approach to the exhibition itself. Museum Docent Mary Therese Grund generously shared her knowledge of American art and American music. Our data files were regularly fattened by research assistants Deirdre Kint and Jessica Crittenden, both seconded to the Virginia Museum by their school, the Randolph Macon Woman's College.

Good things come in fine packages. For this handsome publication and the images therein, I thank editor Rosalie West, graphic designer Jean Kane, photographers Katherine Wetzel and Denise Lewis, and videographers Ruth Twiggs and Bruce Berryhill (who are also to be commended for the accompanying video). The related exhibition was designed by David Noyes and produced by Richard Woodward and his staff, including Carol Moon, Kathy DeHaven, Michelle Edmonds, and Mary Brogan. We are also grateful to Sandy Rusak and her staff in Education and Outreach, especially Les Smith and Ron Epps for aspects of our public programming. And we thank Lisa Hancock and her staff in the Registrar's Office. Over the course of this project, we have enjoyed the the support of our Director, Katharine C. Lee; our Deputy Director, Carol Amato; and Peter Wagner and Sharon Casale in our Development Office. To our patrons whose fiscal generosity enables the museum to create these programs, again deepest thanks.

When I stand back and look at such a gathering of American artworks—some famous, some not—but all inviting avenues to aesthetic thinking in this country over the past several centuries, one of Walt Whitman's many phrases comes to mind: "I hear America singing."

David Park Curry
Curator of American Arts
Virginia Museum of Fine Arts

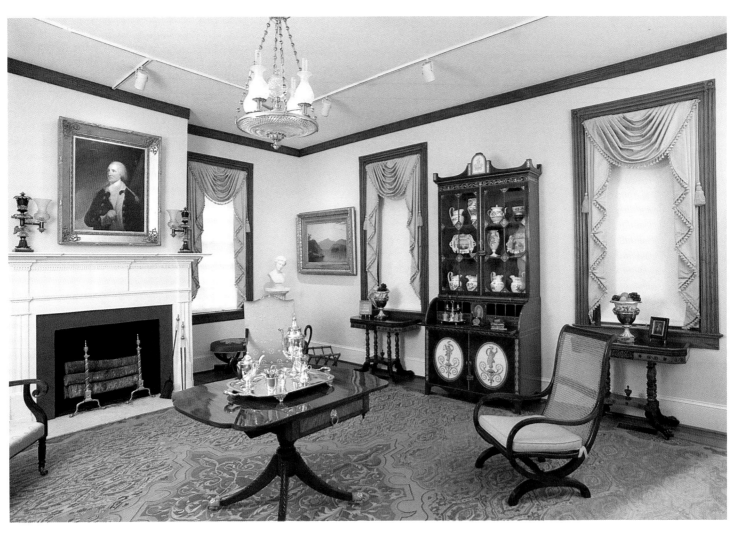

The Mildred Warner House, interior

A Usable Past:
Jack Warner Collects American Art

Throughout history, artists have been visionaries.
They were the ones who dreamed about the future.

— Jack Warner

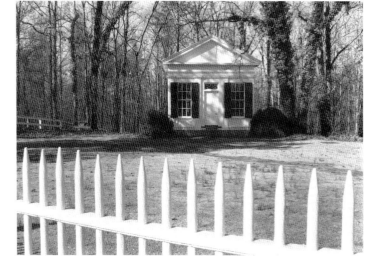

Figure i **The Gainesville Bank,** 1835, now stands on the edge of the golf course at the NorthRiver Yacht Club in Tuscaloosa, Alabama.

Coming around a sharp curve on New Watermelon Road, in the outskirts of Tuscaloosa, Alabama, one suddenly encounters a diminutive, stark white structure standing back in the woods behind a picket fence (Fig. i). This well-proportioned building, with its door set dead center and flanked by a pair of green-shuttered windows beneath an uncompromising Greek Revival pediment, is the Gainesville Bank—the state's oldest, built in 1835. During the mid nineteenth century the bank issued its own currency. In those days banking was a highly independent enterprise, and Gainesville was a thriving port on the Tombigbee River in Sumter County.

Moved to its present location and restored at the behest of Jonathan Westervelt Warner in 1970, the little bank holds no currency now. Yet it still signals independent enterprise: specifically, a wealth of American art. At the time he acquired the building, Jack Warner—then Chief Executive Officer and Chairman of the Board of Gulf States Paper Corporation—was launching an additional career as an avid collector of Americana. This began as something of a hobby, fostered in part by his mother's interests in historic preservation and further stimulated by his service in the Far East during World War II.[1] Over time he has garnered hundreds of objects, establishing himself as one of the most omnivorous collectors that twentieth-century America has witnessed. As thorough in choosing his artworks as he is in schooling his horses, Jack Warner has long been a leader in the hunt for fine American art (Fig. ii).

Today, the Warner collections literally bracket the city of Tuscaloosa, filling two large architectural complexes—one devoted to work and the other to leisure. Many paintings, prints, and drawings are displayed in the national headquarters building of the Gulf States Paper Corporation or are scattered throughout various NorthRiver Yacht Club buildings, which include a spacious lodge and luxurious golfing, swimming, and dining facilities. Another significant portion of the collection fills an early nineteenth-century house that started out as a modest two-room cabin near what is now downtown Tuscaloosa. The David Warner Foundation restored the house in 1976, naming it after Jack Warner's mother, Mildred Westervelt Warner, who led the Gulf States Paper Corporation through the throes of the Great Depression.[2] A few blocks away, in the shadow of The University of Alabama's vast football stadium, an antebellum mansion— home to the President of the University—features recently restored state rooms filled with yet more artworks from the Warner collection.[3] Still other treasures are to be found in the Warner family's home overlooking Lake Tuscaloosa, or gracing the grounds of all the places just cited. The old bank, for example, now stands on the outermost margins of the golf course, a trenchant reminder of the American notion that leisure is one of the rewards of hard work.

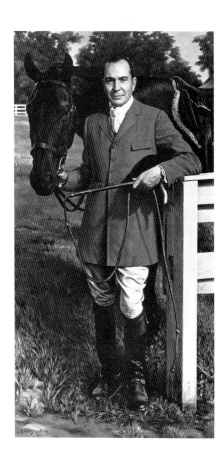

Figure ii An accomplished horseman, **Jack Warner** is posed with his thoroughbred hunter, The Saint. Painting by J. Anthony Wills (1912-1994), oil on canvas, 1970. The Warner Collection of Gulf States Paper Corporation.

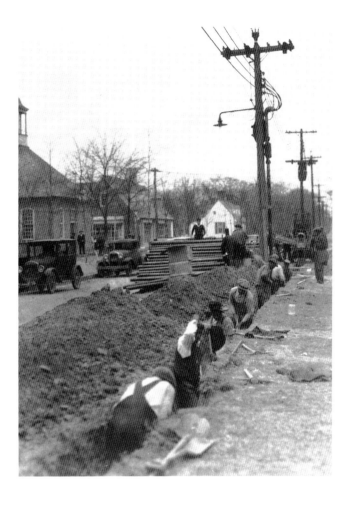

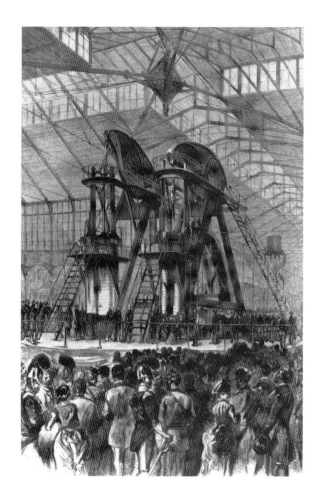

Figure iii Workers bury modern utility lines along **Duke of Gloucester Street** during the early days of renovating Colonial Williamsburg. Automobiles were not banned on this street until 1974.

Figure iv Proudly displayed at the Philadelphia Centennial, the powerful **Corliss Engine** symbolized America's emergence as an international industrial power. Theodore Russell Davis, "Our Centennial: President Grant and Dom Pedro Starting the Corliss Engine," wood engraving, *Harper's Weekly*, 27 May 1876.

Only a dreamer could put such collections together. "I'm an incurable artoholic," Warner cheerfully reports. To view the Warner holdings as a single entity requires a good bit of driving and a strong visual memory. Yet if the myriad objects seem to blur into a colossal horn of artistic plenty, individual analysis of specific pieces reveals an overall collecting pattern. Warner's choices have been consistently guided by a strong underlying ethos—his belief in the classic version of the American Dream, first articulated by historian James Truslow Adams in 1931:

> The American dream that has lured tens of millions of all nations to our shores . . . has not been a dream of merely material plenty. . . . It has been a dream of being able to grow to fullest development as man and woman, unhampered by the barriers which had slowly been erected in older civilizations, unrepressed by social orders which had developed for the benefit of classes rather than for the simple human being of any and every class. And that dream has been realized more fully in actual life here than anywhere else, though very imperfectly even among ourselves. It has been a great epic and a great dream. What, now, of the future?[4]

Adams's anticipation of future developments probably did not include the technological explosion that has led to today's "information age." Indeed, when he fought to call his book *The American Dream*, his publisher rejected the title, supposing that book buyers would never pay three dollars for a "dream."[5] But this was, and is, short-sighted. The concept has proved an immensely fluid one, with multiple applications, made by varying constituencies, for sometimes conflicting purposes.[6] Adams might be pleased that our recent browse for "American Dream" on the Internet recorded 2,122,342 web sites, ranging from automobile advertisements to political commentary to quotes from such television personalities as Roseanne Barr and Aaron Spelling.

Adams codified the American Dream just as the Colonial Revival was drawing to a close with major collecting and preservation projects such as the foundation of John D. Rockefeller's Colonial Williamsburg (1926) (Fig. iii) and Henry Francis du Pont's Winterthur Museum (1930). But dreams of available land, civic freedom, and material abundance have always shaped the American cultural experience, from the days of the earliest explorers and settlers four centuries ago to the emergence of the United States as a formidable world power by the turn of the twentieth century. Many of the works chosen by Jack Warner trace these dreams in paint, marble, or bronze. As the collector has noted, "Throughout history, artists have been visionaries. . . . They were the ones who dreamed about the future."[7]

Particularly after World War II, scholars have tried to reconcile apparent polarities in widely espoused American values. How, for example, can our idealism regularly frame its most altruistic goals in materialistic terms?[8] If automobile ads on the Internet suggest the commercial side of the dream, collecting American art of recognized quality surely lifts materialism, so often associated with the American national character, to sublime heights. As a nation, we have become skilled at holding apparent antitheses in suspension. Walt Whitman observed more than a century ago:

> Do I contradict myself?
> Very well then I contradict myself,
> (I am large, I contain multitudes.)[9]

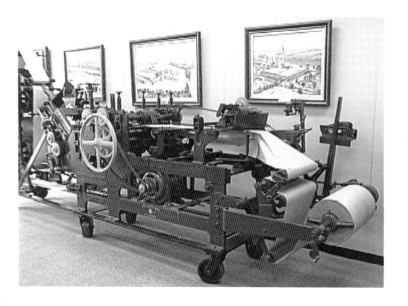

Figure v In 1902, Herbert E. Westervelt patented his design for a machine to make folding grocery bags. **Old No. 8-D,** shown here, is the last such machine. Built in 1915, it was in service for sixty-four years. The Warner Collection of Gulf States Paper Corporation. Video still.

Often, as will be seen in the artworks selected for this book, these polarities appear together in an American picture, lending it both visual and psychological tension.

The values expressed by Adams's version of the American Dream became solidified in the late nineteenth century, coincident with the advent of what is now Gulf States Paper. Key to that value system was the identification of a useable past, whether actual or fancied—a trend that became increasingly evident in painting, literature, even journalism as a response to the trauma of the Civil War and the subsequent arrival of culturally diverse immigrants in large numbers.[10] The concern for preserving America's past became a widely discussed topic during the nation's 100th birthday year, when hundreds of thousands of visitors attended the 1876 Centennial Exhibition in Philadelphia.[11]

The Centennial also celebrated America's emergence as an industrial giant, symbolized for fairgoers by the tireless Corliss Engine (Fig. iv). The history of Gulf States Paper Corporation, founded by Warner's grandfather in 1884, reads like a model of American entrepreneurship. Among the visitors to the Centennial Exhibition was young Herbert Eugene Westervelt, the company's founder. He could hardly have missed the dynamo—one of the most popular exhibits at the fair. Westervelt's own later invention of a machine for making paper grocery bags would ensure the financial viability of the now widely diversified but still privately owned enterprise we know today.[12] Not surprisingly, an art collection of the magnitude held by the Warner family rests on solid fiscal foundations.

One of the bag machines, built in 1915, is displayed as prominently as any painting at the company headquarters (Fig. v). Its label reads in part: "8-D, last of the bag machines built on H. E. Westervelt's 1902 patents. On this invention Gulf States Paper established its reputation in the paper industry and laid the foundations for national diversification." The company also displays a collection of European and American prints documenting the early paper-making trade (Fig. vi).

Figure vi Belin and Bethmont, **Le Papier,** published in *Journal des mères et des enfants,* Paris, ca. 1850. The Warner Collection of Gulf States Paper Corporation.

While the Westervelt family history stretches back to the early days of New Amsterdam,[13] a pragmatic Yankee ingenuity as well as a jaunty, Horatio Alger-like optimism can be associated with the growth of the firm. Joining his brother Edd, who carried on a wholesale paper business from the basement of his grocery store in South Bend, Indiana, Herbert Westervelt relied upon hard work to parlay his mechanical aptitudes, management skills, and family ties into the company now managed by the fourth generation of his descendants.[14] Warner tells this down-to-earth story of his grandfather:

> Herb had perfected his machine to make a square bottomed bag. . . . His E-Z Opener bags combined the best of both worlds—a strong, heavy paper and a square bottom. Folded, its bottom faced the front; opened, it stood erect, ready to be filled without a struggle. . . . In his hotel room he'd practice opening the bags in the way now mastered by every supermarket sacker. When Herb called on a customer, his "jerk" was perfected to open the bag with a flick of the wrist at the first try.[15]

Despite the depth and significance of the fine and decorative art collections he has assembled, Jack Warner remains as down to earth as his forebears, exercising his own sense of freedom and responsibility as both businessman and art collector. He tells newcomers to collecting, "You've got to get that tingling feeling. If you don't have that, you'd better get an adviser."[16] This happens only "about once out of every 1,000 paintings," he confesses.[17] The artists who painted his pictures fascinate Warner. "I find that they were very much like me, and I am very much like them!" he says. "They were all individualists. They were all romanticists. They all had a sense of humor. They were all trying to find themselves."[18]

Trying to define a single national "self" was an enterprise that occupied many an American writer—whether journalist, historian, novelist, or poet— well into the twentieth century.[19] Perhaps the quest was doomed to fail from the outset. As St. John de Crèvecoeur commented in his *Letters from an American Farmer* (1782), "Here individuals of all nations are melted into a new race of men, whose labours and prosperity will one day cause great changes in the world." Indeed, today there is actually no identifiable ethnic majority in America.[20]

Our artists, too, have shared in this quest. If one sought to gather together a group of American painting, sculpture, and decorative art that clearly embodies multiple American dreams, it would be hard to top the sampling presented in this book. Critic Robert Hughes has observed that the images made by American artists "inscribe our beliefs, our dreams—our story":

> The fact of immigration lies behind America's worship of origins, its intense if erratic piety about the past. . . . In America the past becomes totemic, and is always in a difficult relationship to the great central myth of American culture, the idea of progress and newness. For the New World really *was* new, at least to its European conquerors and settlers. It fostered a passionate belief in reinvention and in the power to make things up as you go along, which is an important form of freedom. This and a hankering for origins are both strong, contradictory urges. They produce closely twined feelings: on the one hand a sense of freedom to act in the present and future, and on the other a nostalgia for the past. . . . The art Americans have made often testifies to this.[21]

Warner comments, "Me? I'm a flag-waving, nostalgic American. I love American art."[22]

Certainly, America's idealistic commitment to progress is based on the concept of human perfectibility, while the Protestant ethic of hard work and individual achievement predates the doctrine of equality, a legacy from the American Revolution. Warner sees Asher B. Durand's *Progress* (Pl. 8), which occupies a prominent spot in his company's headquarters complex, as:

> a symbol of constant change . . . of new ideas and inventions that create widespread repercussions. The effects of change are considered to be good or bad according to the goals and ideals of individuals, groups, or even a whole nation. Whether or not we attach the idea of "improvement" to the word progress, the painting certainly makes us aware of the rippling effects of history, touching all people regardless of origin or occupation. *Progress* is especially poignant to us today because of our nation's present awareness of ecology and industry's acknowledged awareness of social responsibility. Today, conservation—the wise use of our natural resources—is as fully important as wise preservation—the safekeeping of our nation's important records and symbols of goals and accomplishments. Both the goals and accomplishments are evidence of the moral and spiritual attitudes and values that were the cornerstones of America's greatness.[23]

To establish a collection of this breadth and depth is a remarkable achievement. While one of the largest such collections in private hands today, it began relatively modestly, as is often the case with American collectors.[24] Warner's first significant purchases in American art were ornithological prints by John James Audubon (Fig. vii), acquired in the late 1940s for a few hundred dollars each, even though "everyone thought I was frivolous."[25] He now has a complete set; they have proved a remarkably strong investment (as has American art in general over the past quarter of a century). Warner next acquired some of Charles Bird King's stirring portraits of Native American chieftains (Pl. 2) in 1970, and like many American businessmen of the period, soon found that he had a strong general interest in the arts of the American West. "They were my first love—I was always a cowboy at heart," he says.[26] The appeal of such pictures for

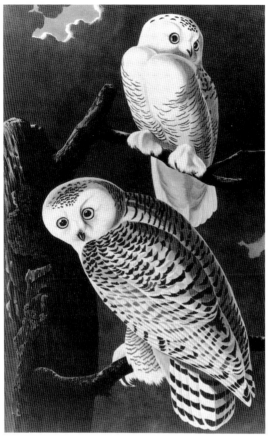

Figure vii John James Audubon (1785–1851), **Snowy Owl,** hand-colored engraving, from *The Birds of America,* 1838, plate 121. The Warner Collection of Gulf States Paper Corporation.

Figure viii Alfred Jacob Miller
(1810–1874), ***The Lost Greenhorn,***
1851, oil on canvas. The Warner Collection
of Gulf States Paper Corporation.

Figure ix

Figure x

Figures ix, x Seen against antique cut-glass
windows, a 425-pound **Howitzer,** made in
1872, becomes a work of art at the North-
River Yacht Club. On the grounds outside,
another cannon, an 1864 Dahlgren Howitzer
mounted in a **gun boat,** becomes an un-
expected, eye-catching garden ornament.
Both from The Warner Collection of Gulf
States Paper Corporation. Video stills.

American captains of industry during the boom economy of the 1970s and 1980s is not
hard to understand—the American cowboy is one of the last great mythological heroes
to be created in western culture. As a symbol, the cowboy represents the freedom to act
and the courage to take responsibility for one's actions.[27] Western humor is also part of
Warner's collecting ethos. Gazing at Alfred Jacob Miller's *The Lost Greenhorn* (Fig. viii),
for example, he can chuckle about an English chuckwagon cook who insisted on riding
out on his own and soon got lost in the vast reaches of the American plains.[28] But this
picture hangs in Warner's own corporate headquarters office, along with other western
pictures (such as Fig. 11). It is not too tall a tale to suggest that such a picture serves
as an artistic warning to do one's homework in what is, after all, a highly competitive
business environment.

Over the past twenty years, the Warner collections have expanded to include major
works by most of America's finest artists, not to mention substantial holdings in important
American and French furniture, ceramics, and glass of the early nineteenth century.
The collector's interests embrace not only entire buildings, but also architectural frag-
ments and even some antique cannons (Fig. ix) and the occasional beached gun boat
(Fig. x). Such military memorabilia serve to recall Warner's service in the 124th Cavalry
on the Burma Trail in China during World War II.

After his return to the United States, Warner and his wife Elizabeth put up a small
garden temple behind their first house (Fig. xi), designed, he says, using a "bottle and
a couple of pieces of string."[29] However modest Warner's tools, the garden embodies
both an artistic distillation of Warner's experiences in Asia and a harbinger of the ele-
gant headquarters building he would erect during the 1970s. The garden features archi-
tectural fragments incorporated into a fantasy world, all the more surprising for being
hidden behind a straightforward facade that gives no hint of what is to come.[30] Such a
garden also reveals the desire for a dream environment that is expressed not only in

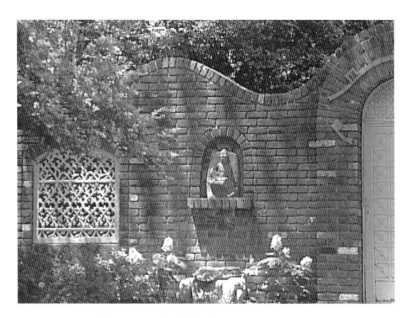

Figure xi **A small exotic garden** behind Mr. and Mrs. Warner's old house is the forerunner of the Gulf States Paper Corporation's headquarters building. Video still.

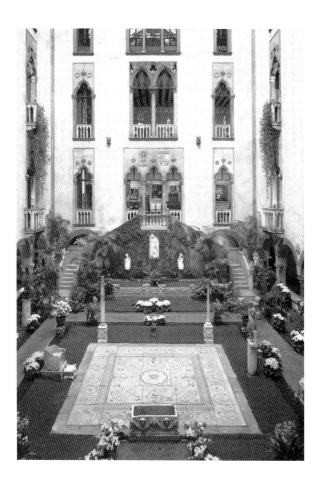

Figure xii Inner court of **Isabella Stewart Gardner Museum,** Boston.

many American paintings but also in elaborate, well-known American architectural fantasies, such as Isabella Stewart Gardner's villa on the Fenway in Boston. There, a discrete exterior masks an exuberant Italianate courtyard, littered with bits and pieces of old European structures and filled with hothouse plants intended to whisk visitors from the dreary urban realities of a Massachusetts winter into a magical world of perpetual springtime (Fig. xii).

If there is one subject type lacking in the Warner collections, it is urban imagery, represented only by a few pieces of porcelain decorated with early nineteenth-century views of Baltimore, Philadelphia, and Washington (Fig. xiii; see also Fig. 16). The sense of escape into Arcadian realms, free of the woes of urban development, is central to the experience of these collections.

To come upon the headquarters building for the first time is to enter a seemingly fanciful Shangri-La. The design of this enormous structure (Fig. xiv), floating serenely in landscaped grounds populated by peacocks, guinea fowl, and other exotic birds, was inspired by the Imperial Palace at Kyoto. Within these light-filled spaces, one is more likely to notice a precocious grey parrot, able and willing to sing The University of Alabama's fight song, than to sense 160 purposeful employees going about their daily tasks in an art-rich working environment (Fig. xv). *The Falls of Kaaterskill* by Thomas Cole (Pl. 4) holds one wall. Asher B. Durand's *Progress* (Pl. 8) holds another. At the far end of a long corridor one glimpses Frank Duveneck's *Miss Blood* (Pl. 19), William Merritt Chase's *Young Girl on an Ocean Steamer* (Pl. 23), or Martin Johnson Heade's *Two Hummingbirds* (Pl. 13). The possibilities seem limitless—but look quickly. The same pictures will not necessarily be in the same place on a subsequent visit. One might be lent to a significant exhibition elsewhere; another might have been sold (Fig. 32) or traded. Warner and his colleagues like to move the paintings, to see them freshly in new juxtapositions. There is nothing static about this lively, still-growing collection.

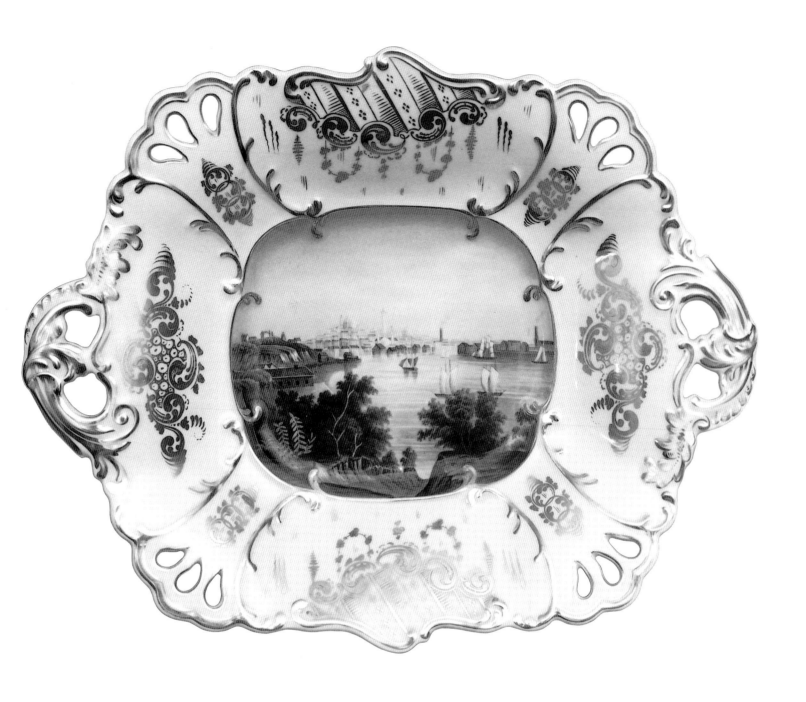

Figure xiii Urban views are scarce in the
Warner Collection. This English piece is
decorated with an early view of Baltimore.
Cake Plate, English, probably Worcester,
ca. 1840, porcelain. The Warner Collection
of Gulf States Paper Corporation.

Figure xiv Inner courtyard, **Gulf States Paper Corporation national headquarters,** Tuscaloosa, Alabama.

Figure xvi This view of the **Mildred Warner House** shows both the original cabin and the grand two-story addition built in the 1830s. The whole was restored and furnished with art and antiques in 1976.

Figure xv **"Bama,"** a grey parrot, likes to greet visitors at the Gulf States headquarters building with running commentary interspersed with the fight song of the University of Alabama. Video still.

Figure xvii **Jack Warner** relaxing under the benevolent gaze of Robert Edge Pine's life portrait of George Washington (see also Pl. 1). Video still.

Elsewhere, at the Mildred Warner House, more of a period-room atmosphere prevails, but again, the collections are dynamic and ever-changing. One would never guess that the old Moody house had been "a bit of a mess" when Warner acquired and renamed it:

> Nothing in it was straight, no two columns equidistant, no windows or doors square, and no floor or ceiling level. The plaster was rotten, and the original wood floor was covered with layers of worn wood and linoleum. But in the eyes of (Jack Warner), the old residence was a quaint but beautiful link with America's past, a choice bit of nostalgia that just needed the helping hand of a restorer (Fig. xvi).[31]

Now, Warner's affinity for soothing color schemes—moss green, warm peach, or creamy yellow, all with plenty of white—provides an ideal home for pictures, sculpture, and decorative art that was initially intended to enhance domestic surroundings (see color plate opposite p. 1). There, one may encounter a relaxed Jack Warner (Fig. xvii), his long-limbed frame stretched out in a period chair, communing with a portrait of George Washington (Pl. 1), contemplating a landscape by Sanford Gifford (Pl. 10), or perhaps examining one of his numerous clocks (Fig. xviii) that bear likenesses of George Washington—clearly the ultimate hero for this graduate of Washington and Lee University. He says:

> . . . don't be surprised if you should visit the Mildred Warner House . . . and find me sitting quietly in almost any room in the house with a cup of coffee in my hand and staring at the wall. . . . I'm just looking at a picture, and I'm closer to heaven than I'll ever be in my life.[32]

Elsewhere, he notes, "A collection is not a single example by every artist in chronological order, but rather an expression of the collector's taste. It may involve a broad spectrum, but it also most certainly will include several examples by favorite artists and none by others. Of course, all the paintings in your collection are your friends."[33] In our current enterprise, we can explore only the tip of Warner's densely packed artistic environment, drawing from the extensive corporate collections of Gulf States Paper Corporation and the David Warner Foundation. Our purpose is to celebrate the beauty of unspoiled nature, the struggles of a growing nation, and the sheer aesthetic vitality of American Dreams as captured in masterworks by some of our greatest painters. What do you see when you contemplate an American landscape painting, or a portrait, or a genre scene? We hope you will make new friends. DPC

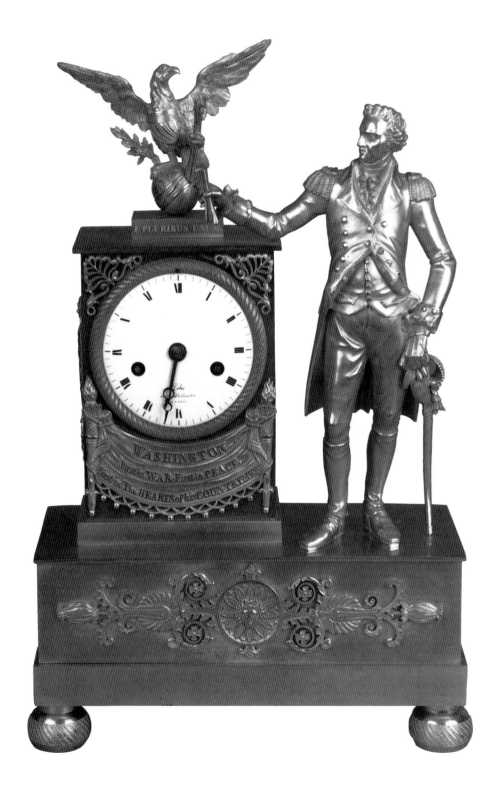

Figure xviii The Warner Collection is rich in Washingtoniana, ranging from life portraits to decorative arts, including this clock. Jean-Baptiste Dubuc (French, active 1790–1819), **Clock with Figurine of George Washington,** ca. 1815–17, gilt bronze with enamel dial and clock works. The Warner Collection of Gulf States Paper Corporation.

Notes

1 Paintings by Constable and van Ruysdael were among the artworks Mildred Westervelt Warner used to decorate the house in which Jack grew up. With her "enthusiasm for renovation, restoration, and the perpetuation of Southern heritage [Mrs. Warner] played a significant part toward the decoration and furnishing of the president's mansion at The University of Alabama, the restoration and decoration of the Gorgas Home (family residence of Alabama's famous yellow fever fighter, General William Gorgas), dating from 1829, and the purchase and initial decoration of the antebellum Governor's Mansion (home of an Alabama governor when Tuscaloosa was the capital, 1826–1846), which the Warners gave to The University of Alabama for use as its University Club." Jack Warner and Doris B. Fletcher, *Progress* (Tuscaloosa: Gulf States Paper Corporation, 1984), p. 105. Clearly Mrs. Warner set a strong example for both preservation and public benefaction. Warner's sojourn in Asia fostered his interest in the sculpture of Oceania, pieces of which embellish his headquarters building.

2 Diane D. Burrell, "The Mildred Warner House: American Art, American Spirit," *Southern Accents*, vol. 8 (November–December 1985), pp. 62-71, 138; Frederick D. Hill, "The Warner Collection of Gulf States Paper Corporation, Tuscaloosa, Alabama," *The Magazine Antiques*, vol. CXXX (November 1986), pp. 1036-45.

3 "The President's Mansion, The University of Alabama, Tuscaloosa, Alabama," brochure, The University of Alabama.

4 James Truslow Adams, *The Epic of America* (Boston: Little, Brown & Co., 1931), p. 405. Adams's other books include titles such as *The Founding of New England*, *Revolutionary New England, New England in the Republic*, and *The Adams Family*, emphasizing the widespread privileging of the upper Northeast and people of Anglo-Saxon descent in the development of this concept.

5 Allan Nevins, *James Truslow Adams: Historian of the American Dream* (Urbana: University of Illinois Press, 1968), p. 68. Adams's *The Epic of America* was actually well received. Translated into nine languages, it was still in print in the 1960s, although by then considerably more scholarship on the topic had appeared.

6 A session titled, "The American Dream: The Private Life of a Public Concept" was proposed for an upcoming annual meeting of the American Studies Association (30 October – 2 November 1997).

7 Warner, *Progress*, p. 202.

8 David Potter, "The Quest for the National Character," in Luther S. Luedtke, ed., *Making America: The Society and Culture of the United States* (Chapel Hill: University of North Carolina Press, 1992), p. 23.

9 Walt Whitman, "Song of Myself" (1855) from *Leaves of Grass*, cited in Luedtke, *Making America*, p. 20. Some of the most frequently discussed polarities in American life are equality and individualism; individualism and conformity; idealism and materialism; equality and achievement; individualism and commitment. Ibid., p. 23.

10 John Higham, "The Immigrant in American History," in *Send These to Me: Immigrants in Urban America*, rev. ed. (Baltimore: The Johns Hopkins University Press, 1984), pp. 3-28.

11 See Alan Axelrod, ed., *The Colonial Revival in America* (New York: W. W. Norton, 1985).

12 The machine is based on Westervelt's patent, no. 709,129, granted September 16, 1902. Warner, *Progress*, p. 38. Today the firm's divisions include Natural Resources, Wood Products, and Pulp and Paperboard. The last division alone has plants in five states.

13 The Westervelt family landed at New Amsterdam on May 24, 1662, after six weeks on the high seas. They lived on Long Island for ten years before moving to New Jersey; then, in 1765, to Fishkill in Dutchess County, New York. Subsequent generations moved further westward, to Indiana and Illinois.

14 Warner, *Progress*, p. 204. An Illinois native, Jack Warner moved to Tuscaloosa as a child at the time his grandfather consolidated the company as Alabama's first modern pulp and paper mill in 1929.

15 Warner, *Progress*, p. 40.

16 Patrick Pacheco, ed., "The Top 100 Collectors in America," *Art & Antiques*, vol. XVIII (March 1995), p. 110.

17 John E. Buchanan, Jr., "The Warner Collection of the Gulf States Paper Corporation," *American Art Review*, vol. 5 (Winter 1993), p. 65.

18 Jack W. Warner, *Thoughts of an Avid Collector* (Tuscaloosa: Gulf States Paper Corporation, 1984), unpaginated.

19 See Luedtke, "The Search for American Character," in Luedtke, ed., *Making America*, pp. 1-33.

20 Crèvecoeur cited in ibid., p. 3. Luedtke goes on to note that the 1990 census counted a population of 248.7 million persons, including 15% of British descent, 13% German, 12% African, 9% Hispanic, 8% Irish, 8% Native American, 7.3% Asian.

21 Robert Hughes, "American Visions," *Time* (Special Issue, Spring 1997), p. 7.

22 Buchanan, "The Warner Collection," p. 65.

23 Warner, *Progress*, pp. xiii, xiv.

24 David Park Curry, "Charles Lang Freer and American Art," *Apollo*, vol. CXVIII (August 1983), pp. 164-79; David Park Curry, *Fabergé: The Virginia Museum of Fine Arts* (Richmond: The Virginia Museum of Fine Arts, 1995), pp. 26-27.

25 Jack W. Warner, interviews with author, 14–17 May 1997. Such engravings now sell for $30,000 to $50,000 each.

26 Ibid.

27 Royal B. Hassrick, introduction to Lonn Taylor and Ingrid Maar, *The American Cowboy*, exhibition catalogue (Washington: American Folklife Center, Library of Congress, 1983), pp. 12-14.

28 The picture is based on an actual incident that occurred during Miller's 1837 western trip with the Scottish sportsman Captain William Drummond Stewart. The artist was charged with recording the hunting trip in pictures, and he missed no opportunity. It seems that Stewart's English cook, seen in the picture on horseback anxiously searching the horizon, went hunting buffalo by himself and got lost. Rescued the next day, he had earned the epithet "greenhorn." Miller like this image and did several versions of it, including the one in the Warner collection and another at the Buffalo Bill Historical Center in Cody, Wyoming. The turbulent sky, wind-swept prairie, and rather melodramatic gesture of the silhouetted figure indicate Miller's talent as a romantic painter, well equipped to convey the beauties as well as the dangers of the Great American Desert.

29 Jack W. Warner, interview with author.

30 The house has since been donated to the University of Alabama for use as a guest house.

31 Burrell, "Mildred Warner House," p. 65.

32 Buchanan, "The Warner Collection," p. 65.

33 Hill, "The Warner Collection," pp. 1039-40.

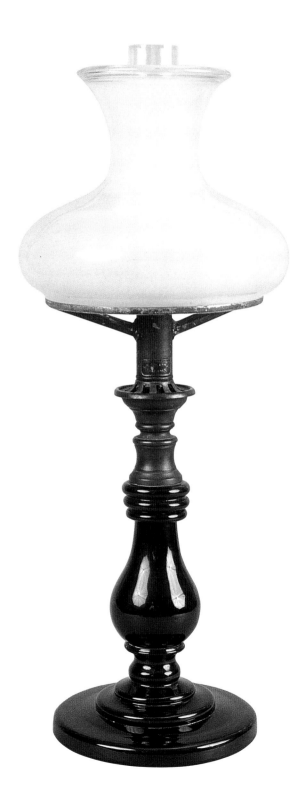

I like this one.
It tells a story . . .

—Jack Warner

The following gallery of thirty color plates, drawn from the collections formed by Jack Warner over the past quarter of a century, will give readers a glimpse of the depth, breadth, and quality of his holdings. Some pictures are famous, others are not; but in each case, quality has been a primary concern of the collector. Every plate is further supplemented with a second work from the Warner collections, illustrated in black and white, along with a piece from the Virginia Museum of Fine Arts. The authors hope that these selections, which encompass the thoughts of artists, patrons, poets, and writers, as well as our own insights, will shed some light on the richly complex and diverse body of work that comprises American art and culture.

Figure xix Early lighting fixtures, signals of an important technological advance during the nineteenth century, are well represented in the Warner Collection. This rare American example depended on a circular fuel tank to provide light without casting a shadow (literally "sinumbra — without shadow"). New England Glass Company, **Sinumbra Lamp,** ca. 1830-35, black-amethyst glass. The Warner Collection of Gulf States Paper Corporation.

Robert Edge Pine
George Washington

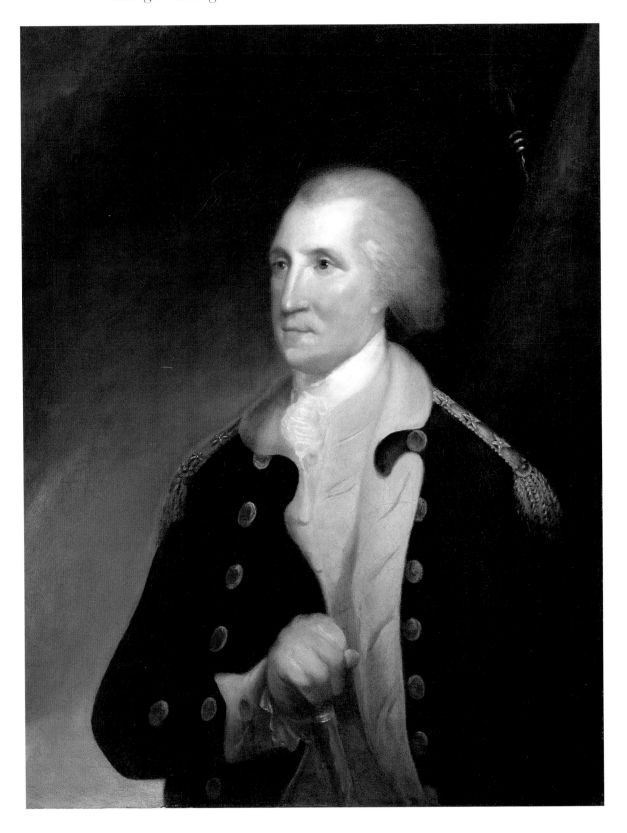

Proceed, great chief, with virtue on thy side,
Thy ev'ry action let the goddess guide.
A crown, a mansion, and a throne that shine,
With gold unfading, WASHINGTON! be thine.

— Phillis Wheatley, *To His Excellency General Washington*, 1775

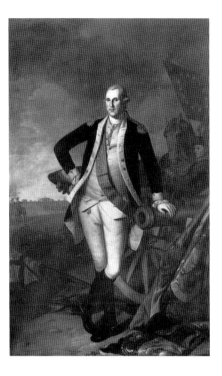

For a largely illiterate eighteenth-century population, the persuasive power of the painter's brush equaled pen and sword. Like revolutionary pamphlets that were surreptitiously posted, then shouted to eager listeners, visual images instructed viewers in social, cultural, and political ideas, exciting allegiance—and inciting rebellion. But America's dream of freedom was often couched in the language of aristocracy. Wheatley's words resonate with images of heroism drawn from centuries of nondemocratic rule. So does this portrait by Robert Edge Pine (Pl. 1).

London born, Pine represents the first generation of American painters to use artistic training in the service of rebellious politics. Until the 1770s, Pine enjoyed a considerable patronage among England's elite, but his choice of radical political subjects led to his rejection by the Royal Academy. In 1784, he arrived in Philadelphia with a letter of introduction to George Washington. This entrée gave Pine the opportunity to create one of the few life portraits of America's revolutionary leader, a man who would soon become a symbol of democratic freedom.

Pine's canvas, intended to invoke loyalty and admiration, is everything that Sir Joshua Reynolds, first President of the Royal Academy, might have hoped for—an artist "cannot make his hero talk like a great man; he must make him look like one" (1771). Yet this portrayal is also everything that Reynolds, his Tory peers, and their Royal patron feared: an academic portrait employed for "radical" ends.

The irony of Pine's radicalism and its dangerous manipulation of academic codes was that its roots were in England—in the Glorious Revolution of 1688, which marked the rise of Whig government, the evolution of English liberty, and the canon of common law. The Glorious Revolution inspired a cult of virtue that cloaked Britain's future in honor, glory, and freedom from tyranny. The resulting social contract regulated the relationship between colonists and crown. This contract empowered Americans to challenge the Englishness of policies enacted by Parliament and King, investing revolutionary portraits with political resonance.

In Charles Willson Peale's full-length image (Fig. 1), Washington is depicted at the Battle of Princeton, where the artist himself served. To command the viewer's allegiance, Peale gives Washington an air of confidence and power reinforced by the imagery of cannons and troops. Yet Peale's vision is clearly of a Republican leader: having refused to rule as a supreme power, Washington defies aristocratic conventions by wearing no wig in his public portrait. And the only crown in this image is a symbolic one—pictured on the flag at Washington's feet.

Portraits of Washington reached an international audience; indeed, Peale's *George Washington* was sold to a Spanish nobleman impressed by the leader's rejection of throne and crown. That Washington's virtue should draw widespread admiration comes as little surprise when we consider his place in American myth. A century after the revolution, Washington's virtue resounds again, couched in the tale of the hatchet and cherry tree, as celebrated by P. McCallion's still life (Fig. 2). "I cannot tell a lie," Washington is supposed to have said. The question here is, what sorts of truth do pictures tell? SJR

Plate 1 **Robert Edge Pine** (1730–1788) *George Washington*, circa 1785, oil on canvas, unsigned, 35 x 28 inches. The Warner Collection of Gulf States Paper Corporation.

Figure 1 **Charles Willson Peale** (1741–1827) *George Washington*, 1779, oil on canvas, inscribed lower left: *C.W. Peale, pinxt/ Philadelphia 1779*, 96 ½ x 61 ½ inches. Virginia Museum of Fine Arts, Lent by Mrs. J. Woodhull Overton.

Figure 2 **P. McCallion** (active 1890–1900) *The Little Hatchet That George Washington Cut Down the Cherry Tree With*, 1890, oil on canvas, inscribed lower right: *P. McCallion/1890*, 12 ³⁄₁₆ x 10 inches. The Warner Collection of Gulf States Paper Corporation.

Charles Bird King
Black Hawk (Makataimeshikiakiah)

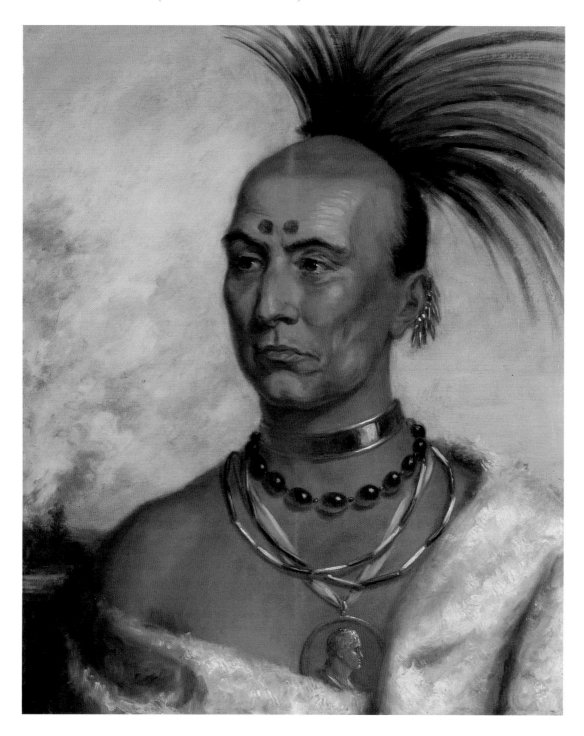

The sun rose dim on us in the morning,
and at night it sank in a dark cloud.

That was the last sun that shone on Black Hawk.

He is now a prisoner to the white men;
they will do with him as they wish.
But he . . . is not afraid of death.

Black Hawk is an Indian!

— Anonymous Native American oration, *Farewell to Black Hawk*, 1832

Black Hawk, chief of the Sauk Indians, fought to preserve his nation's hunting ground from American settlement. Defeated in 1832, he was escorted to Washington, D.C., to satisfy the demands of the Great White Father and to be immortalized in a portrait by Charles Bird King.

King sensitively captures Black Hawk in a likeness considered highly exact in its day (Pl. 2). It is a character study of sorts, but King also reveals the tragic position of a conquered chief. Black Hawk maintains his dignity with an upright posture and wears the traditional Indian dress that marks him as a hero among his own people. Yet posed before a glimpse of landscape that evokes the lost lands of his forefathers, Black Hawk is reduced to a souvenir. Around his neck, entwined with native adornments, hangs a United States government Peace Medal, the ironic symbol of the white man's victory over Native American peoples.

On contract from the United States government, King painted 143 portraits of American Indians between 1821 and 1842. This contract served the economic interests of both parties: it kept King busily employed in the development of the War Department's Indian Gallery, and it sanctified government acquisition of Indian lands and resources. For artists and craftsmen anxious to capture and preserve the ideological symbols of the New World, the Native American was a popular subject. Ironically, once displaced by economic interests, and painted for economic profit, the Indian was adopted as a commercial symbol for American tobacco merchants (Fig. 3).

These visual and sculptural images record both the Romantic ideal of the "noble savage" and the exotic filter through which Native Americans were perceived. Until the late twentieth century, when more open-ended interpretations of our past began to appear, Indians were cast as the "other" in official versions of American history. Fascination with the "other" has been broadened in the American imagination and resonates in George Luks's highly sculptural portrait of American sports hero Gene Tunney (Fig. 4). A forthright pose of the head, coupled with a stripped-down bareness unsoftened by modern manners and dress, links the boxer with immigrant roots to the deposed Indian chief. In each case the battle for survival invests the sitter with stirring heroism.

SJR

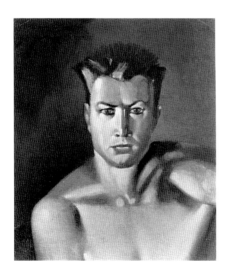

Plate 2 **Charles Bird King** (1785–1862)
Black Hawk (Makataimeshikiakiah), circa 1833, oil on panel, unsigned, 24 x 19 ¾ inches. The Warner Collection of Gulf States Paper Corporation.

Figure 3 **Unknown artisan**
Indian Chief, nineteenth century, painted wood, 72 ¼ x 8 ¼ x 14 ½ inches. Virginia Museum of Fine Arts, Gift of Mr. Paul Mellon.

Figure 4 **George Luks** (1866–1933)
Gene Tunney, circa 1930, oil on canvas, inscribed lower right: *George Luks*, 20 x 24 inches. The Warner Collection of Gulf States Paper Corporation.

François Joseph Bourgoin
Family Group in a New York Interior

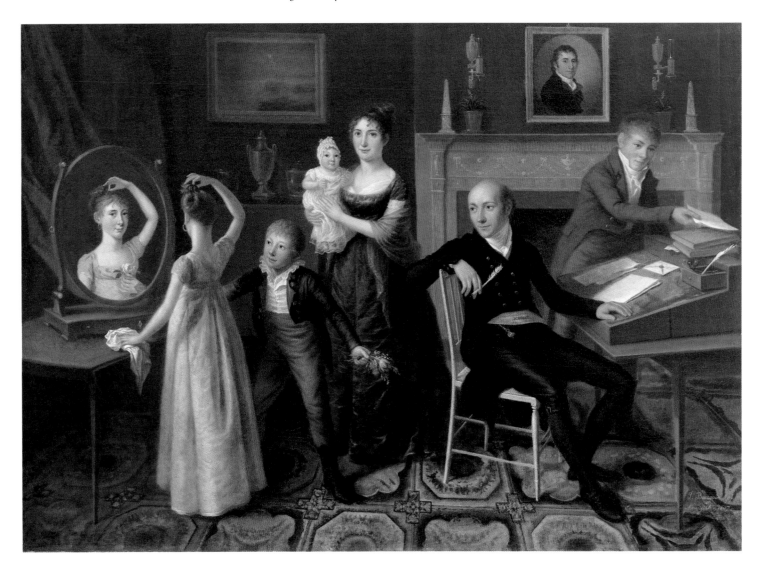

Will you tell me how to prevent riches from producing luxury? Will you tell me how to prevent luxury from producing effeminacy, intoxication, extravagance, vice and folly?

— John Adams to Thomas Jefferson, 21 December 1819

When François Bourgoin portrayed an unidentified New York family in 1807 (Pl. 3), he delineated much more than their likenesses. For this group portrait, the French émigré produced a conversation piece—a centuries-old European pictorial convention in which multiple figures seem to interact informally. But poses in group portraits are calculated; and, by accident or design, they project social relationships. They also offer visual inventories of possessions, inanimate and animate—displays of materialism that provoked discomfort in segments of American society from the outset.

An earlier conversation piece by a southern limner (portraitist) differentiates the status of a slave nursemaid and the sons of a Virginia gentleman (Fig. 5). Separated visually from her charges by the vertical corner of the house, the African American girl is relegated to a secondary position in the painting's margin and, by inference, to the periphery of the family.

Bourgoin, in his later painting, addressed not only familial relationships but also prevailing gender roles among the urban middle class of the North. The father pauses at his desk, pen in hand, to cast a loving look at his wife and children. His eldest son helps him tend to the business of the outside world. With a warm, outward gaze, the mother invites the viewer into the domestic realm. Ensconced in the heart of home and family, she holds the baby and supervises the younger children at play. Her daughter, lifting her hair in an attempt to appear older, poses self-consciously before a mirror as her brother offers flowers for her gown. Her bust-length reflection emulates the oval portrait above the fireplace—the face of a smiling relative who, at night, is illuminated by Argand lamps, the latest in household lighting.

Bourgoin's painting also conveys the prosperity of a young family that can afford the newest fashions in clothing and furnishings in the Neoclassical style. The sitters appear to be patrons of the arts, as well, exhibiting a recent engraving after John Vanderlyn's 1803 painting, *View of the Western Branch of the Fall of Niagara.* This visual catalogue of luxuries, however, is moderated by an allusion to the couple's commitment to their respective labors. In the early decades of the new nation, an increasingly affluent middle class still adhered to an abiding Protestant and republican moralism. Beginning in the colonial period, opulence and luxury were equated with decadent European aristocracy; tenets of discipline, moderation, and industry informed social behavior. In the guise of his famous alter ego, Poor Richard, Benjamin Franklin warned: "Silks and Satins, Scarlet and Velvets put out the Kitchen Fire" (1758)—a fear of the degenerating effects of luxury echoed years later in John Adams's letter to Thomas Jefferson.

In the mid nineteenth century, artist Louis Lang celebrated a profusion of silks and satins in his genre painting, *The Sewing Party* (Fig. 6). Around the portico of a home, he assembles the members of a benevolent society; their colorful hoop skirts bloom like flowers around the edges of the steps. Still a generation away from the unabashed flaunting of personal wealth that would come in the Gilded Age, the ladies temper the display of their abundance by sewing clothing for the poor.　ELO

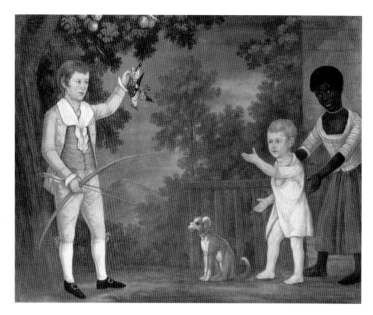

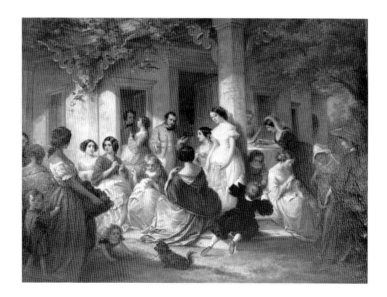

Plate 3 **François Joseph Bourgoin** (active 1762–1817)
Family Group in a New York Interior, 1807, oil on canvas, inscribed lower right: *J. Bourgoin pt/ New-york—1807,* 30 x 24 inches. The Warner Collection of Gulf States Paper Corporation.

Figure 5 **Attributed to the Payne Limner**
Alexander Spotswood Payne and His Brother, John Robert Dandridge Payne with Their Nurse, 1790–1800, oil on canvas, unsigned, 56 x 69 inches. Virginia Museum of Fine Arts, Gift of Miss Dorothy Payne.

Figure 6 **Louis Lang** (1814–1893)
The Sewing Party, 1857, oil on canvas, inscribed lower right: *Louis Lang 1857,* 42 ¼ x 57 inches. The Warner Collection of Gulf States Paper Corporation.

Thomas Cole
The Falls of Kaaterskill

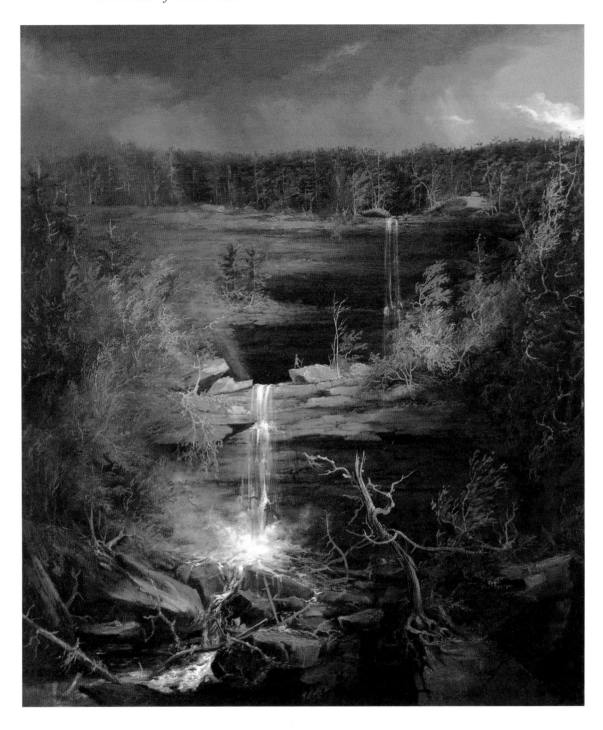

The axe of civilization is busy with our old forests, and artisan ingenuity is fast sweeping away the relics of our national infancy. . . . What were once the wild and picturesque haunts of the Red Man, and where the wild deer roamed in freedom, are becoming the abodes of commerce and the seats of manufactures. . . . Yankee enterprise has little sympathy with the picturesque, and it behooves our artists to rescue from its grasp the little that is left, before it is too late.

— Jasper Francis Cropsey, 1847

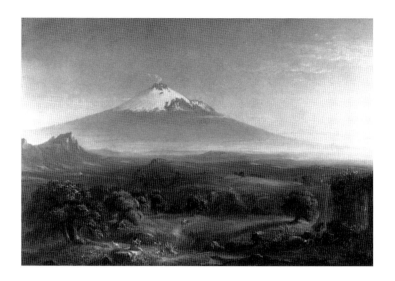

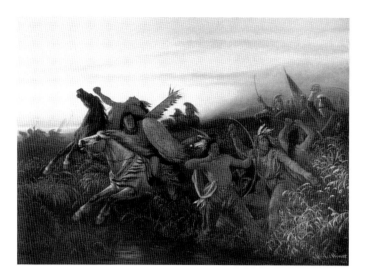

The landscape was fraught with significance for American painters and patrons. Abundant available land was the currency of the covenant between newly arrived Americans and their God in a cultural construct of Manifest Destiny that spelt political and economic freedom for European pioneers at the expense of Native American peoples occupying the land. But even as an American version of the Arcadian dream of rustic simplicity emerged, it became increasingly evident that natural resources were not infinite. With the rise of industrialization during the nineteenth century, images of an unspoiled wilderness engaged American imaginations already dreaming of earlier days. As Jasper Cropsey asserted, "Yankee enterprise has little sympathy with the picturesque, and it behooves our artists to rescue from its grasp the little that is left before it is too late."

By 1825, English-born Thomas Cole was in the Catskill Mountains, preparing carefully observed detailed sketches that culminated in *The Falls of Kaaterskill* (Pl. 4). Cole's composition invites the viewer on a panoramic journey through the vast American wilderness. Traveling from edge to center of the canvas, the eye passes thundering torrents and twisted trees, climbing upwards to encounter the elegant figure of a lone Native American, tiny yet compelling against the towering cliffs. This single brave is a harmonious part of the natural whole—yet the balance is a delicate one.

Cole's painting speaks to the "course of empire," an eighteenth-century theme that fueled contemporary American philosophy at the time of his career. This idea suggested that the transformation from a wild to a civilized state followed a natural progression from East to West, placing American development on a continuum linking the new republic with the classical traditions of ancient Greece and Rome. This link may be clearer in Cole's small *View of Mount Etna* (Fig. 7), where a smoking Italian volcano and ancient ruins encouraged an American belief that the power of the old world was played out.

To reinforce his philosophical focus on the Kaaterskill Falls, Cole edited his actual experience of the site, leaving out wooden walkways and viewing platforms built before 1825 for urbanized tourists wanting to glimpse the great American wilderness from a comfortable standpoint. Not only the American landscape but also its original occupants were subject to editing if Manifest Destiny was to function. Charles Wimar's stirring image (Fig. 8) captures the drama in which a drive for economic profits was reinforced by Jacksonian policies of Indian removal and western expansion. In pitting "primitive" natives against "civilized" invaders, Wimar foreshadows the fall of the Indian in the name of progress.

SJR

Plate 4 **Thomas Cole** (1801–1848)
The Falls of Kaaterskill, 1826, oil on canvas, inscribed lower right: *T. Cole;* verso: *Falls of Kaaterskill Tho. Cole 1826,* 43 x 36 inches. The Warner Collection of Gulf States Paper Corporation.

Figure 7 **Thomas Cole** (1801–1848)
View of Mount Etna, circa 1842, oil on canvas, inscribed bottom center: *T. Cole,* 15½ x 23 inches. Virginia Museum of Fine Arts Purchase, The Adolph D. and Wilkins C. Williams Fund.

Figure 8 **Charles Wimar** (1828–1863)
Indians Pursued by American Dragoons, 1855, oil on canvas, inscribed lower right: *Charles Wimar/ Düsseldorf 1855,* 33 x 46 inches. The Warner Collection of Gulf States Paper Corporation.

23

School of George Caleb Bingham
The Trapper's Return

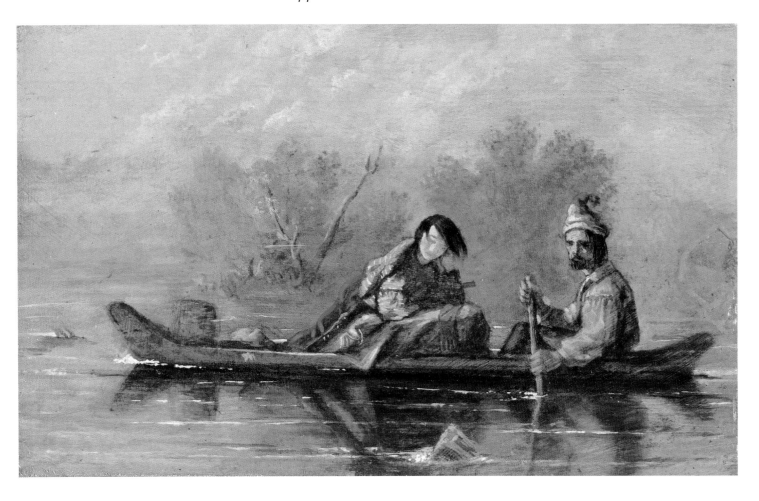

. . . I reckon I got to light out for the Territory ahead of the rest, because Aunt Sally she's going to adopt me and sivilize me, and I can't stand it. I been there before.

— Mark Twain, *The Adventures of Huckleberry Finn*, 1884

As settlers and speculators moved west for land, raw materials, and profit, they tried to transform their new surroundings into the image of the urban East. Simultaneously, rugged individuals eager to escape the constrictions of "civilized" society continually "lit out for the Territory," as Mark Twain's Huckleberry Finn put it. This duality informs *The Trapper's Return* (Pl. 5), a tiny panel based on George Caleb Bingham's full-scale canvas, *Fur Traders Descending the Missouri* of 1845.

Here, afloat on a glassy river, the trapper and his son pass through a western landscape. Celebrating a neutral space where Man and Nature exist in harmony without the benefit of eastern niceties, this glimpse of the Missouri River records a place where racial differences are fluid. In the West the occupants of the fragile craft are man and child, but by the standards of the East they would have been more precisely differentiated, as we can surmise from the title first applied to Bingham's original canvas: *French Trapper and His Half-Breed Son.*

As civilization carved its way into the frontier in a manner represented by George Catlin's *Grand Detour* (Fig. 9), economically ambitious speculators shored up their campaign for resources and profits by borrowing from the harrowing experiences of the earliest colonists. Branding the West as dangerous, they transformed the philosophical ideal of the "noble savage" into the emotional threat of the heathen beast. In John Mix Stanley's melodramatic *Indian and Virgin* (Fig. 10), the Native American embodies a threat to the very purity of advancing civilization, for, amidst a wild setting of rocks and crags, a kidnapped white-clad virgin struggles against his savage power in a metaphoric battle for supremacy.

SJR

Plate 5 **School of George Caleb Bingham** (1811–1879)
The Trapper's Return, circa 1851, oil on panel, unsigned, 4 x 6 ½ inches. The Warner Collection of Gulf States Paper Corporation.

Figure 9 **George Catlin** (1796–1872)
Grand Detour, Upper Missouri Showing the High "Table Land" in the Distance, circa 1865–1870, oil on board, unsigned, 18 ½ x 24 ¼ inches. Virginia Museum of Fine Arts, The Paul Mellon Collection.

Figure 10 **John Mix Stanley** (1814–1872)
Indian and Virgin, 1847, oil on panel, inscribed lower left: *Stanley 1847,* 12 ½ x 17 ½ inches. The Warner Collection of Gulf States Paper Corporation.

Edward Hicks
The Peaceable Kingdom

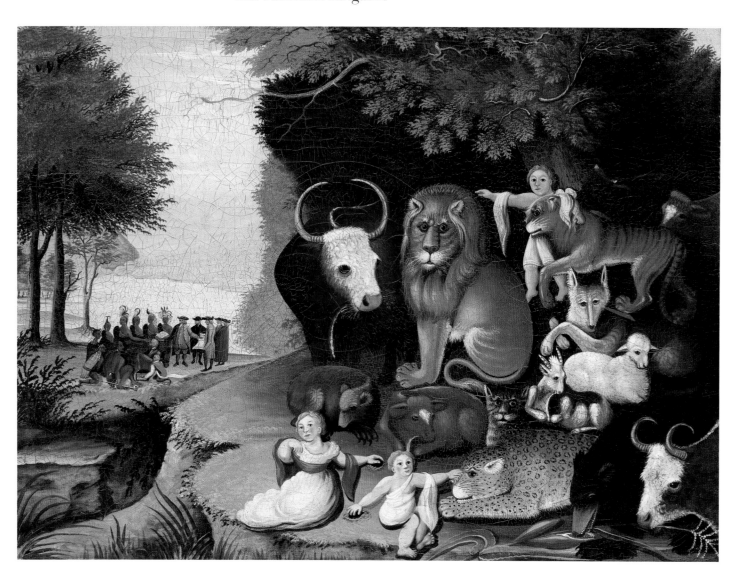

The wolf also shall dwell with the lamb, and the leopard shall lie down with the kid; and the calf and the young lion and the fatling together; and a little child shall lead them.

— Isaiah 11:6

Childlike innocence is a major component of the idealized American character, and the leap from Isaiah's biblical prophecy of man's redemption to a more nationalistic vision of America as a New Eden, typified by religious and political freedom, is not hard to find in American art. An extensive series of closely related pictures by Edward Hicks celebrates William Penn's settlement of Pennsylvania as a colony where newcomers of any religious persuasion could take refuge from political persecution. In his many versions of this subject, Hicks's very approach to *The Peaceable Kingdom* (Pl. 6)—based upon the continuous reuse of flattened images borrowed from various print sources—underscores his own unworldly training, which was far from the sophisticated studios of academic art.

By the time Hicks took up his brush, there was a palpable need for a refreshed sense of American innocence, marked by the renewed religious spiritualism of the Second Great Awakening (ca. 1795-1835). The metaphorical union of Isaiah's kingdom and the New World had already served the revolutionary ideology of patriotic Americans by symbolizing the inevitable victory of American virtue against the corruption of European tyrants. By the 1830s, this ideology had been absorbed by a dominant national identity that tied notions of Manifest Destiny to white dominance. As Andrew Jackson's policies of Native American displacement were combined with expanding industrialism in the North and the struggle to maintain a slave-based economy in the South, the great experiment of a free New World was quite literally beginning to come apart at the seams.

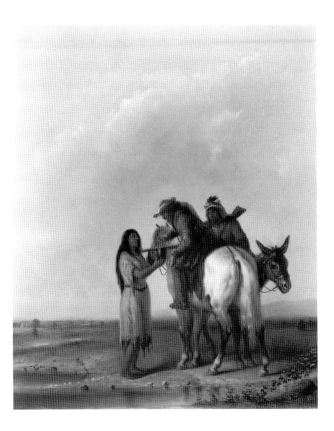

Yet Hicks's vision of Eden was more than just a childlike backward view. The picture was painted shortly after Jackson's Removal Bill (1830) led to the "trail of tears" along which eastern tribes were forced to march westward beyond the Mississippi River. At the left of his picture, Hicks includes an image of William Penn signing a peace treaty with Native Americans. On the one hand, this exchange acknowledges the promise of new lands available to European settlers. On the other, given the political developments of the early 1830s, it reiterates the ironic poignancy of relations between settlers and the earlier occupants of the land.

By 1850, when Alfred Jacob Miller painted *The Thirsty Trapper* (Fig. 11), America had absorbed the Indian territories east of the Mississippi. Miller's gentle image seems to express hopes of a harmonious union. The scene is set by a river, a quintessential metaphor of religious rebirth. The trapper receives water from an Indian woman. The guide who watches the exchange is undoubtedly meant to be read as a man of mixed race. Seated astride a mule rather than a horse, he has both a dark skin and a luxuriant beard. He wears feathers on his headgear but also sports a western neckerchief. Indeed, he appears the image of the faithful guide immortalized by Charles Averill's 1849 bestseller, *Kit Carson:* "a noble figure of the hunter-horseman, half Indian, half white man in appearance. . . ." Miller's vision of peaceful coexistence looks ahead to eventual amelioration of cultural differences at a time when women in American culture were regularly seen as keepers of domestic tranquility and moral rectitude.

Ornamental domesticity is the main thrust of a key basket (Fig. 12), one of a virtually identical series crafted by an unknown artisan in Virginia. As a somewhat impractical receptacle for household keys, it calls into question the need for secure locks and barriers. At the same time, its bold outline, balanced symmetry, and flat patterning offers variations on a theme, just as Hicks's series of Peaceable Kingdoms does. Stamped geometric patterns and inlaid red leather hearts appear on each of the known key baskets. Hicks's sixty versions of his favorite subject are all painted in a colorful, two-dimensional style as in *The Peaceable Kingdom.* Filled with good intentions, such works of art remind us that artists may choose to seek the ideal, despite the harsh realities of what they observe. SJR

Plate 6 **Edward Hicks** (1780–1849)
The Peaceable Kingdom, circa 1833, oil on canvas, unsigned, 17 ½ x 23 ½ inches. The Warner Collection of Gulf States Paper Corporation.

Figure 11 **Alfred Jacob Miller** (1810–1874)
The Thirsty Trapper, 1850, oil on canvas, inscribed lower right: *A. Miller 1850,* 20 x 24 inches. The Warner Collection of Gulf States Paper Corporation.

Figure 12 **Unknown artisan (probably Richmond)**
Key Basket, circa 1830–60, embossed, appliquéd and stitched leather, 9 x 9 x 6 inches. Virginia Museum of Fine Arts, Gift of Dr. and Mrs. Franklin P. Watkins and Gift of Miss Miram Hill, by exchange.

Frederic E. Church
Above the Clouds at Sunrise

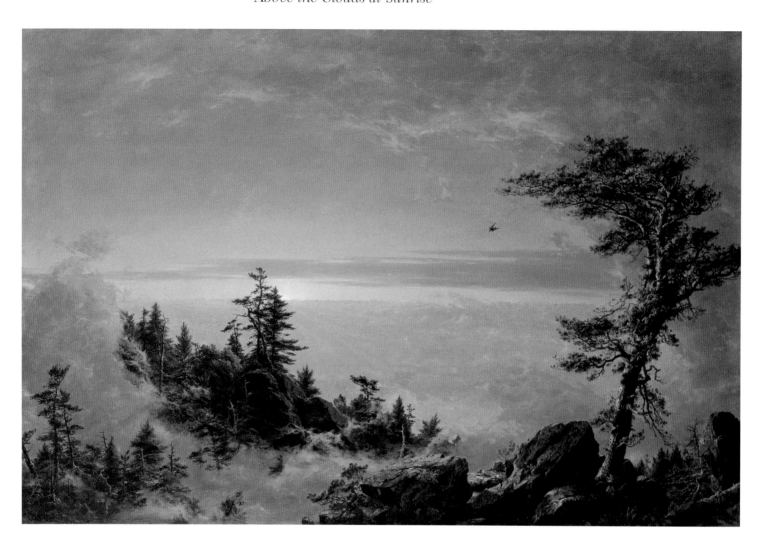

I looked with awe at the ground I trod on, to see what the Powers had made there, the form and fashion and material of their work. This was that Earth of which we have heard, made out of Chaos and Old Night. Here was no man's garden. . . . It was not lawn, nor pasture, nor mead, nor woodland. . . . It was the fresh and natural surface of the planet Earth, as it was made forever and ever . . .

— Henry David Thoreau, "Ktaadn and the Maine Woods," 1848

Exercising the mesmerizing power of the sublime, Frederic Edwin Church uses vivid color like a heavenly beacon to dazzle the viewer into flights of fancy, soaring *Above the Clouds at Sunrise* (Pl. 7). Clearly, Church intended to overwhelm the senses with his picture.

During the eighteenth century, authors and artists regularly used the sublime as an aesthetic device to coax emotive reactions from their audiences. In *A Philosophical Enquiry into the Origin of Our Ideas of the Sublime and Beautiful* (1747), Edmund Burke described it as a "passion caused by the great . . . in *nature* . . . in which all [the soul's] motions are suspended . . . [and] so entirely filled with its object, that it cannot entertain any other. . . ."

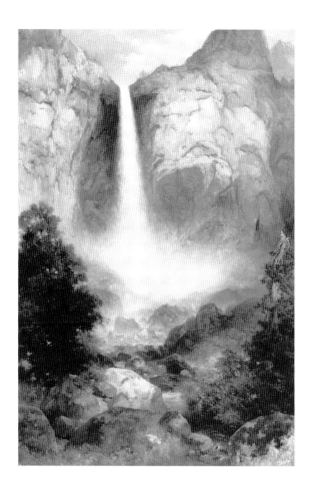

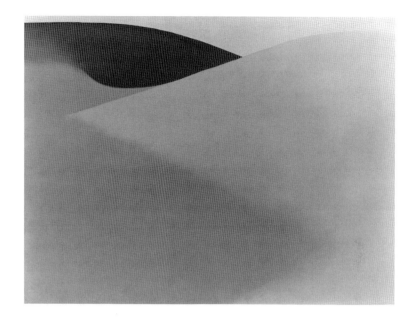

Although sources record that Church was not a religious man, the correlation between his pictures and the experience of conversion was not lost on many Americans during this era of spiritual renewal. British art critic John Ruskin argued for careful observation in art, believing that such precision led to spiritual communion. Yet Church's approach to painting was sustained not only by the overt religious convictions that dominated popular culture in mid nineteenth-century America, but also by earlier precedents. Rhetorical accounts of religious conversion anticipate the language of the sublime early in the colonial period. Jonathan Edwards wrote in 1733, "there is such a thing as a Spiritual and Divine Light, immediately imparted to the soul by God, of a different nature from any that is obtained by natural means."

Certainly, there is nothing "natural" about Church's studio canvas. His acute sensitivity to the sublime combines with other tools in the kit of the nineteenth-century landscape painter. Church coupled his facility for close observation with an overall panoramic vision, techniques he learned from his teacher, Thomas Cole. Church also exercised a scientific understanding of atmospheric effects and was thoroughly familiar with the formulaic elements of earlier European landscape painting, such as contorted trees, breaking skies, and dramatic emerging light. The skillful blending of all these elements made Church phenomenally successful in his own lifetime.

The sublime in American landscape painting did not disappear in the ever-more secular twentieth century. Thomas Moran's *Bridalveil Falls* (Fig. 13) floods the senses with a rush of water that cascades into a rainbow of color and light. And Georgia O'Keeffe, freed from Ruskinian detail by the advances of modern abstraction, uses graphic shapes and modulated tones to transport the viewer into the vastness of an empty desert (Fig. 14).

SJR

Plate 7 **Frederic E. Church** (1826–1900) *Above the Clouds at Sunrise*, 1849, oil on canvas, inscribed lower right center: *F.E. Church/1849*, 27 ¼ x 40 inches. The Warner Collection of Gulf States Paper Corporation.

Figure 13 **Thomas Moran** (1837–1926) *Bridalveil Falls, Yosemite Valley*, 1904, oil on canvas, inscribed lower left: *MORAN. 1904*, 30 ¼ x 20 inches. Virginia Museum of Fine Arts, Gift of Mr. and Mrs. Huntington Harris.

Figure 14 **Georgia O'Keeffe** (1887–1986) *Blue Sand*, circa 1959, oil on canvas, unsigned, 30 x 40 inches. The Warner Collection of Gulf States Paper Corporation.

Asher B. Durand
Progress (The Advance of Civilization)

[Progress] *is purely American. It tells an American story out of American facts, portrayed with true American feeling by a devoted and earnest student of Nature.*

<p style="text-align:right">— The Knickerbocker, 1 July 1853</p>

For his optimistic, urban audience of 1853—including the reviewer for *The Knicker-bocker* magazine—Asher B. Durand's *Progress* (Pl. 8) provided an "American story" of western expansion and technological advancement. From left to right, the idealized landscape offers a narrative in three episodes. The first alludes to America's past, when native peoples freely inhabited the wilderness. Within a dense tangle of rocks and trees, Durand pictures several Indian figures who pause on a promontory to survey the valley below. The light of dawn reveals the "facts" of America's present, the inhabitation of the land by Euro-Americans who cleared the forest and established such bustling towns as the one below. Within the radius of a white church steeple Durand catalogues stages of industrial and commercial development. From riverside mills and factories, goods are transported by train, canal barges, steamboats, and wagons.

These rapidly expanding networks connected with other villages, towns, and cities. They also conveyed people to the frontier. The traveler on the road at bottom right sets out on foot toward unsettled territories, foretelling "The Advance of Civilization." Also symbolic of America's future are the telegraph poles and wire that, in the words of poet William Cullen Bryant, "annihilated both space and time in the transmission of intelligence." The inventor of the electricity-based telegraph, Samuel F. B. Morse, articulated the nineteenth-century belief that technology was heaven sent. For his demonstration to Congress in 1844, Morse wired the biblical message implicit in Durand's later painting: "What hath God wrought!"

Like his friend Durand and other New York artists who painted vistas of the Hudson River Valley, Jasper Cropsey focused primarily on untouched nature in *Mt. Jefferson, Pinkham Notch, White Mountains* (Fig. 15). Cropsey's large canvas nevertheless includes in the foreground a tiny lumberjack and sawmill. Less celebratory than Durand's *Progress*, his image also captures the sad truth that the advancement of civilization—homesteading and the establishment of industry—corresponded with the destruction of primeval forests.

Landscape dissolves into cityscape on a large French porcelain urn with two decorative panels that record Philadelphia's urban development (Fig. 16). One side offers a panoramic vista along the Schuylkill River, including a glimpse of the Tucker Porcelain Works at the far right. At the time the Neoclassical urn was produced, the Tucker works were the only American firm even remotely capable of producing such high-quality porcelains as this European example. Like the tiny image of the sawmill in Cropsey's *Mt. Jefferson* or the more detailed indications of industry in Durand's *Progress*, this French urn made for an American buyer reminds us that anything from a metaphoric canvas to a decorative urn could link art and commerce. ELO

Plate 8 **Asher B. Durand** (1796–1886) *Progress (The Advance of Civilization)*, 1853, oil on canvas, inscribed lower left: *A. B. Durand 1853*, 48 x 72 inches. The Warner Collection of Gulf States Paper Corporation.

Figure 15 **Jasper Francis Cropsey** (1823–1900) *Mt. Jefferson, Pinkham Notch, White Mountains*, 1857, oil on canvas, inscribed lower left: *J.F. Cropsey/1857*, 31 ½ x 49 ½ inches. Virginia Museum of Fine Arts Purchase, The J. Harwood and Louise B. Cochrane Fund for American Art.

Figure 16 **Unknown French manufacturer** *Urn with Views of Philadelphia*, circa 1830, porcelain, 15 9/16 x 11 ¼ inches. The Warner Collection of Gulf States Paper Corporation.

William Sidney Mount
Any Fish Today?

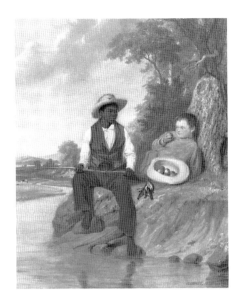

For, eschewing books and tasks
Nature answers all he asks;
Hand in hand with her he walks,
Face to face with her he talks,
Part and parcel of her joy,—
Blessings on the barefoot boy!

— John Greenleaf Whittier, "The Barefoot Boy," 1856

By the time William Sidney Mount exhibited *Any Fish Today?* (Pl. 9) at the 1858 National Academy of Design, his portrayals of everyday life had long been favored by New York patrons. Mount, who was instrumental in introducing genre painting to American audiences thirty years earlier, drew inspiration from rural scenes around his native Long Island. His images of country living appealed to urban sophisticates with a growing nostalgia for an idealized, simpler time. At mid century, an era of increased economic and political instability, Mount's depiction of a healthy and happy boy would have stimulated a sense of yearning similar to that prompted by John Greenleaf Whittier's popular poem, which opens: "Blessings on thee, little man, Barefoot boy, with cheeks of tan!" Both underscored the prevailing romantic notion that innocent children were closest to nature. Such imagery, put forward in prose, poetry, painting, and illustration, offered viewers momentary escape from the burden of adult responsibility and the sense of loss that came with urbanization and industrialization.

However, Mount's cheerful boy—like most rural children—does not entirely escape work. A contributor to the family economy, he catches fish for barter or sale. The doorway of the home he visits exhibits an axe at the left and a gun at right—indication that this household is also reliant on natural resources in the back country. But the cane-bottomed chair, book, and carpet intimate a middle-class gentility.

The two lads in James Clonney's *Boy Fishing* (Fig. 17) are also living off the land. With his fishing pole resting across his knee, a black child returns the gaze of a white boy of similar age. Between them are the fruits of their individual labors—a string of porgies and a hat full of apples. While their mutual regard suggests a possible trade, the outcome is uncertain. Clonney, attuned to current public debate over the annexation of Texas and the possible extension of slavery in the Union, crafted an ambiguous image where compromise hangs in the balance.

In his *Fisher Boy* (Fig. 18), first modeled in 1841, sculptor Hiram Powers produced another—though more controversial—homage to boyhood. Residing in Italy, the American created a classicized adolescent youth who holds a conch shell to his ear. Powers explained that "the character is modern," intentionally devoid of the traditional historical allusions that would "justify entire nudity." Powers had difficulty selling the sculpture to his squeamish countrymen, long uncomfortable with unclothed figures. Over the next decade the artist sent versions for exhibit in London and New York "to catch fish for me." It drew American customers after 1851 when Powers gained international acclaim for his *Greek Slave* (see p. 53, Fig. 37). ELO

Plate 9 **William Sidney Mount** (1807–1868) *Any Fish Today?*, 1857, oil on panel, inscribed lower right: *Wm. S. Mount 1857*, 21 ¼ x 16 ¼ inches. The Warner Collection of Gulf States Paper Corporation.

Figure 17 **James G. Clonney** (1812–1867) *Boy Fishing*, 1845, oil on panel, inscribed lower right: *CLONNEY, 1845*, 17 x 14 inches. The Warner Collection of Gulf States Paper Corporation.

Figure 18 **Hiram Powers** (1805–1873) *Fisher Boy*, 1846–50, marble, inscribed on base, rear: *H POWERS Sculp.*, 58 x 18 x 16 inches. Virginia Museum of Fine Arts, Lent by Mrs. W. Taliaferro Thompson.

Sanford Gifford
Sunset in the Shawangunk Mountains

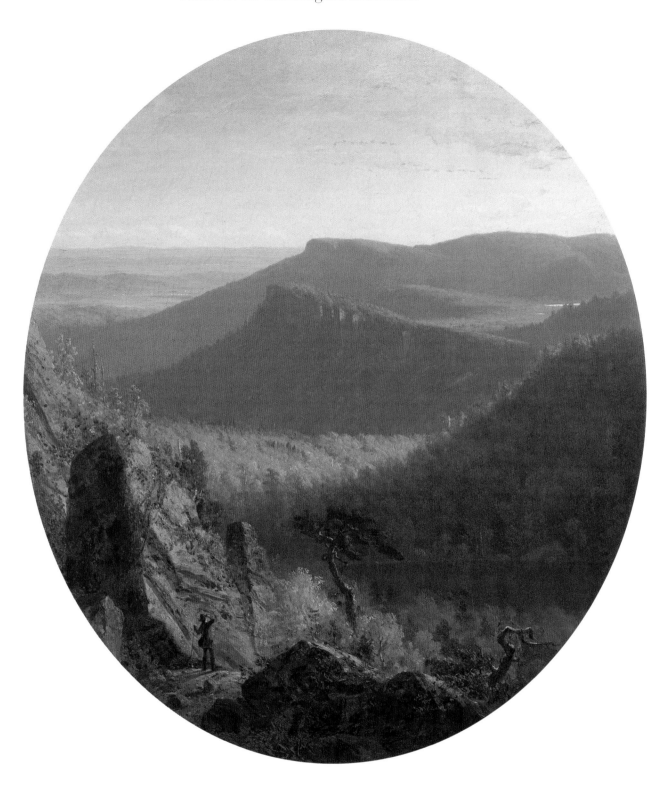

There appears to be something in the pursuit of mechanical invention which has . . . a divine title, 'lords of creation.'

— quoted in *Scientific American*, 1847

By 1850, the term "art" had multiple meanings. It signified not only painting and sculpture, but also industrial activity. If the fine arts were crucial to America's cultural aspirations, the mechanical arts were equally important for a nation dreaming of economic supremacy. A trade journal, noting the "special affinity between the Machine Age and the New Republic," asserted that "never before has there been anything like the violent coming together of advanced art and savage nature" (1850). As the one tamed the other, the ideological construct of "the machine in the garden" became a fixed part of American culture. Often, little details in American landscape paintings record machinery—railroad trains, factory stacks, sawmills—creeping into the unspoiled wilderness. Sanford Gifford had firsthand knowledge of machines in gardens. Born in Saratoga County, New York, he moved to the bank of the Hudson River, across from the Catskill Mountains, beginning his artistic career in the same area where his father had established an iron foundry.

A single figure populates Gifford's *Sunset in the Shawangunk Mountains* (Pl. 10). He gazes out over the vast topography, almost with the proprietary air of a real estate developer. In the farthest distance minuscule white roofs or tents give evidence of advancing settlement, and the picture's title seems to indicate the twilight of untouched virgin forests, meadows, and mountains. In a related picture, using the same scale and "tondo" (circular) format of old master painting, Gifford's *Morning in the Adirondacks* (Fig. 19) takes the next step, indicating the dawning of an industrial age. Freshly cut stumps of trees punctuate the terrain. Some of these have been used to construct a rustic hut, the harbinger of more elaborate buildings to come. Again the notion of the "course of empire" governs an artificial reconciliation of agrarian ideals with the promise of lucrative factories. A tiny figure in a canoe barely disturbs the still waters of this essentially positivist vision of American resources and their potential use.

For Arthur B. Davies, painting sixty years after America's industrial development began in earnest, faith in a harmonious reconciliation between nature and industry had been severely shaken by the economic excesses of the Gilded Age as well as bloody international unrest. Escaping into an imaginary world, he used a *Line of Mountains* (Fig. 20) as an evocative stage backdrop, against which a frieze of Grecian-inspired figures float dreamily, without reference to mundane commercial matters. SJR

Plate 10 **Sanford Gifford** (1823–1880)
Sunset in the Shawangunk Mountains, 1854, oil on canvas, inscribed lower center: *S. R. Gifford 1854,* 40 ⅞ x 36 inches. The Warner Collection of Gulf States Paper Corporation.

Figure 19 **Sanford Gifford** (1823–1880)
Morning in the Adirondacks, 1854, oil on canvas, inscribed lower center: *S. R. Gifford 1854,* 40 ⅞ x 36 inches. The Warner Collection of Gulf States Paper Corporation.

Figure 20 **Arthur B. Davies** (1862–1928)
Line of Mountains, circa 1913, oil on canvas, inscribed lower left: *A.B. DAVIES,* 18 x 40 ⅛ inches. Virginia Museum of Fine Arts, Gift of a Friend.

Constant Mayer
Recognition

"A house divided against itself cannot stand." I believe this government cannot endure permanently half slave and half free. I do not expect the Union to be dissolved—I do not expect the house to fall—but I do expect it will cease to be divided. It will become all one thing, or all the other.

—Abraham Lincoln, from his debate with Stephen Douglas, 1858

When Constant Mayer exhibited his massive painting *Recognition* (Pl. 11) in June 1866, an accompanying pamphlet explained that, in the battlefield scene of the "late fearful struggle in our own country," one brother finds another dying. The two figures—representing a house divided—had joined different sides in the Civil War. "Such a painting as this," the passage continued, "must always stir our feelings with a throb of sympathy, while it melts us to pity and tenderness."

In Mayer's nonpartisan image, neither man wins—a theme that would have struck a chord in those Americans who yearned for healing and reconciliation after four years of war. Both North and South sustained destruction of property and life; together their combined death toll numbered over 500,000. If the shaken survivors had not witnessed the horror themselves, they had been able to see, for the first time, photographic images of men still lying where they fell.

Mayer, a French immigrant who had gained academic training at the Ecole des Beaux-Arts, produced a bloodless death scene. Heroic in theme and scale, his composition recalls the religious images of Pietàs or Depositions depicted in European art of previous centuries. Mayer further emphasizes the contrast of life and death by placing one man before a verdant forest; his mortally wounded brother leans toward a decaying tree stump.

Equally symbolic, an African American family races toward the dawn of light and Union lines in Eastman Johnson's *A Ride for Liberty* (Fig. 21). They flee the hardships of slavery and its constant threat of family division. Johnson, who traveled to the front with Northern troops, recreated the scene from "a veritable incident . . . seen by myself" near Manassas in March 1862.

Over sixty years and several devastating wars later, John Steuart Curry pictured *The Return of Private Davis from the Argonne* (Fig. 22). Curry had witnessed the funeral of his high-school friend who was among the first American casualties during World War I. From memory, the artist portrayed mourning relatives and citizens of the rural Kansas town as they gathered around the flag-draped coffin. "Bleeding Kansas," which during the Civil War entered the Union as a no-slavery state only after years of territorial violence, later sacrificed its sons on the battlegrounds of France. ELO

Plate 11 **Constant Mayer** (1831–1911) *Recognition*, 1865, oil on canvas, inscribed lower left: *Constant Mayer 1865*, 68 ¼ x 93 ½ inches. The Warner Collection of Gulf States Paper Corporation.

Figure 21 **Eastman Johnson** (1824–1906) *A Ride for Liberty—The Fugitive Slaves, March 2, 1862*, 1862, oil on canvas, inscribed lower right: *E Johnson*; inscribed verso: *A veritable incident in the civil war seen by myself at Centerville on the morning of McClellan's advance towards Manassas. March 2d, 1862/ Eastman Johnson*, 21 ½ x 26 inches. Virginia Museum of Fine Arts, The Paul Mellon Collection.

Figure 22 **John Steuart Curry** (1897–1946) *The Return of Private Davis from the Argonne*, 1928–40, oil on canvas, inscribed lower right: *John Steuart Curry 1931*, 38 x 52 inches. The Warner Collection of Gulf States Paper Corporation.

Winslow Homer
The Noon Recess

It is found that boys as well as girls are easily controlled by the tender and cultivated female teacher, that they yield readily to the voice of kindness, and are not insensible to the peculiar charm of a gentle and loving nature.

—"The New School-Mistress," *Harper's Weekly,* 20 September 1873

The Noon Recess (Pl. 12) is one of a series demonstrating Winslow Homer's awareness of post–Civil War educational philosophies, which depended heavily on the participation of women as teachers in an educational system previously dominated by men. In 1872, a year before Homer painted the schoolroom, *The Ohio Educational Monthly* observed that "the capture of the common school" by female instructors was "one of the most vital social changes wrought by our great civil war." As more women began to take paying positions outside the home, the generally accepted notion of their softening influence was gradually translated from the home into more public spheres. The old image of the disciplinary schoolmaster with his hickory stick gave way to that of the gentle schoolmistress with her books; and the American child was seen as innately good, but in need of benevolent guidance. Here, a young boy is *Kept In* (the earliest title by which the picture is known). He reads while his schoolmates play outdoors—sending the basic message of the Protestant ethic: work proceeds play.

Tiny one-room schoolhouses, often staffed by women, became common in the South following the Civil War. Liberal thinkers recognized the significance of education as a means of giving former slaves and their families a new foundation for economic independence. In E. L. Henry's work (Fig. 23), a tardy little boy tries to enter the schoolroom quietly, but another student looks up at his approach. It is entirely possible that the young truant will be kept in, like Homer's wayward scholar. Nonetheless, he holds under his arm books and a slate—tools for his eventual advancement.

Women were entering professional life, but their path was not an easy one. Although the young female teacher in Homer's school scene seems wistful, the artist also adapted the image in a more detailed, anecdotal woodblock print for *Harper's Weekly,* whose readers would have seen that the teacher appears angry at having to remain in the schoolroom.

Scattered books and papers provide atmospheric details for Homer's picture, whereas the book became the central subject in a series of small pictures by Claude Raguet Hirst (Fig. 24). Actually named Claudine, the artist used the name Claude to conceal her gender from art juries. Her focus on books recalls William John Loftie's *Plea for Art in the House* (1876), one of many nineteenth-century guidebooks that purported to instruct newly affluent women in the mysteries of good taste. Loftie told female readers, "pictures ornament a house more than anything else, but . . . next to pictures I am inclined to place books." DPC

Plate 12 **Winslow Homer** (1839–1910)
The Noon Recess, 1873, oil on canvas, inscribed lower left: *HOMER 1873,* 9 ¼ x 14 ⅛ inches. The Warner Collection of Gulf States Paper Corporation.

Figure 23 **Edward Lamson Henry** (1841–1919)
Tardy, circa 1888, oil on board, inscribed lower left: *E L Henry,* 13 x 10 inches. The Warner Collection of Gulf States Paper Corporation.

Figure 24 **Claude Raguet Hirst** (1855–1942)
Books and Pottery Vase, circa 1895, oil on canvas, unsigned, 7 ⅛ x 10 inches. Virginia Museum of Fine Arts Purchase, Collector's Circle Fund.

Martin Johnson Heade
Two Hummingbirds by an Orchid

To say to the painter, that Nature is to be taken as she is, is to say to the player, that he may sit on the piano.

—James McNeill Whistler, *The Ten O'Clock Lecture,* 1885

"The love of travel was strong within him," wrote Henry Tuckerman of Martin Johnson Heade in *The Book of the Artists* (1867). An incessant wanderer, Heade found himself torn between art and science in an era when art critic John Ruskin's emphasis on the close scrutiny of nature coincided with the emergence of Charles Darwin's theories of evolution. As artists abandoned the romanticized grand tour of Greek and Roman ruins for more rigorous voyages to exotic locations, their pictures explored previously unseen natural wonders and earned Ruskin's praise for "giving persons who cannot travel trust-worthy knowledge."

By late 1863 Heade was in Rio de Janeiro. The following year he exhibited a series of hummingbird pictures as "Gems of Brazil." The artist hoped to publish these pictures as chromolithographs (lithographic prints using colored inks), a practice common at the time. While his original plan was defeated by a much more ambitious, five-volume work already on the market, the impact of Brazil remained strong in Heade's later work.

Having begun as a Victorian painter of flowers and fruit, Heade managed to blend still-life and landscape painting in the best of his hummingbird series. From 1871 until 1901 he mined his "Gems of Brazil" for new works that certainly supply the viewer with "trustworthy knowledge." In *Two Hummingbirds by an Orchid* (Pl. 13) the orchid is a Brazilian *Cattleya Labiata,* while the male hummingbird, a Cora's Shear-tail *(Thaumastura Corae),* dramatically displays his elegant plumage for a female of the species.

Although the well-traveled Titian Peale is best known for scientific illustrations, his effort to translate naturalist data into salable reproductions was similar to Heade's. Peale's *Lepidoptera Americana (Butterflies of North America),* intended to include a hundred color plates, got no further than a "Prospectus" in 1833. During the last years of his life, he created myriad oil illustrations for his unpublished tome. *Morpho Cypris* (Fig. 25) is typical of his painstaking detail and rich color. However, art as well as science again asserts itself. Historian Kenneth Haltman has read Peale's specimen studies as "family portraits," where the dominant male, subservient female, and docile off-spring say as much about the tense dynamics of the Peale family as about the habits of butterflies. As time passes, the evident decorative quality of these pictures stands out from their maker's scientific intentions, recalling the popularity of butterflies during the Aesthetic Movement of the 1880s, when Whistler signed his pictures with a butter-fly cypher and aesthetic considerations dominated advanced art circles.

The abstraction of nature into art seems complete with Georgia O'Keeffe's *Light Iris* of 1924 (Fig. 26). Here a monumentalized, close-up image of a bearded iris is trans-lated into a seductive set of voluptuous curves rendered in broad, shimmering passages of sensuous color.

DPC

Plate 13 **Martin Johnson Heade** (1819–1904) *Two Hummingbirds by an Orchid,* 1875, oil on panel, inscribed lower right: *M J Heade 75,* 15 ½ x 20 inches. The Warner Collection of Gulf States Paper Corporation.

Figure 25 **Titian Peale** (1799–1885) *Morpho Cypris,* 1878, oil on paper, inscribed lower right: *Titian R Peale 1878,* 16 x 12 inches. The Warner Collection of Gulf States Paper Corporation.

Figure 26 **Georgia O'Keeffe** (1887–1986) *Light Iris,* 1924, oil on canvas, unsigned, 40 x 30 inches. Virginia Museum of Fine Arts, Gift of Mr. and Mrs. Bruce C. Gottwald.

Felix O. C. Darley
Gathering Corn in Virginia

[H]is labor is founded on the basis of nature, self-interest; can it want a stronger allurement? Wives and children, who before in vain demanded of him a morsel of bread, now, fat and frolicsome, gladly help their father to clear those fields whence exuberant crops are to arise to feed and to clothe them all, without any part of being claimed, either by a despotic prince, a rich abbot, or a mighty lord —This is an American.

—St. John de Crèvecoeur, *Letters from an American Farmer,* 1782

In his *Gathering Corn in Virginia* (Pl. 14), Felix Darley depicts an extended farm family as it gathers its harvest by hand. Sitting under a tower of bundled stalks, a couple removes and shucks ripened ears of corn. A young drover steadies a waiting team of oxen while the cart is slowly filled, basket by basket. Only the fidgeting child and sleeping dog suggest the tedium of the labor. Otherwise, the figures appear healthy and happy in their communal task.

Darley, who had already gained widespread success as an illustrator in New York and Philadelphia, drew upon an established tradition in American art and literature that extolled rural labor as virtuous and noble. From its earliest pronouncements by Crèvecoeur and Thomas Jefferson—who called those who labored in the earth the "chosen people of God"—the agrarian ideal became an American ideal. The yeoman farmer was imbued with an aura of republican dignity and freedom. Archer Payne, a Virginia planter who had his portrait made around 1790 (Fig. 27), is pictured standing proudly before his newly harvested haystacks. He holds a sheaf of wheat and the handle of a plow—attributes that communicate the abundance of his property as well as his ability to vote as a landowner in the newly formed republic. But Payne's plenteous crops, like those of his contemporaries Jefferson and Crèvecoeur, were farmed by African American slaves.

In the uneasy years of Reconstruction following the Civil War, Darley's bucolic painting provided his northern clientele comforting assurances of racial harmony. There is nothing to characterize the scene as southern except its title and, indirectly, the figure of the African American drover. However, in a shift of conventional portrayal, the black man is not working the field; he watches the labor from above. With a flick of his switch, the oxen—symbolically white and brown—will pull together.

Darley also offered a nostalgic glimpse of a rural past that was vanishing with the introduction of mechanized farm machinery. This cheerful but archaic idyll would complement other such paintings by Winslow Homer and Eastman Johnson or prints by Currier and Ives that lined the walls of urban townhouses in the industrialized North. In George Inness's *Haystack, Montclair* of 1889 (Fig. 28), the abundant American farmscape dematerializes into an evanescent pastoral dream. ELO

Plate 14 **Felix O. C. Darley** (1822–1888) *Gathering Corn in Virginia,* circa 1870, watercolor on paper, inscribed lower left: *F.O.C. Darley,* 17 x 24 inches. The Warner Collection of Gulf States Paper Corporation.

Figure 27 **Attributed to the Payne Limner** *Archer Payne,* 1790–1800, oil on canvas, unsigned, 40 5/8 x 32 1/4 inches. Virginia Museum of Fine Arts, Gift of Miss Dorothy Payne.

Figure 28 **George Inness** (1825–1894) *Haystack, Montclair,* 1889, oil on canvas, inscribed lower right: *G. Inness 1889,* 24 x 38 inches. The Warner Collection of Gulf States Paper Corporation.

William Merritt Chase
Keying Up (The Court Jester)

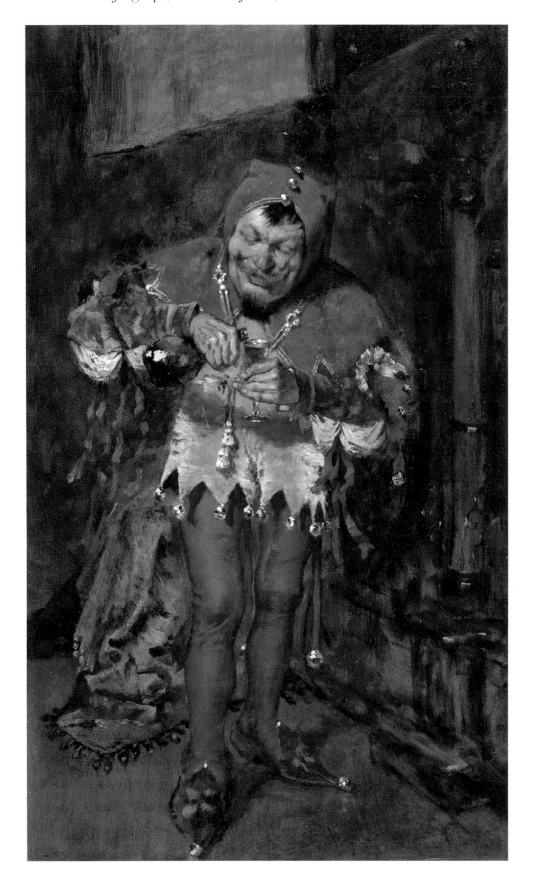

Nor ours the sole gay masks that hide a face
Where cares and tears have left their withering trace,
On the world's stage, as in our mimic art,
We oft confound the actor with the part.

— Tom Taylor and Charles Reade, *Masks and Faces,* circa 1856

Commercialized leisure has been a hallmark of changing American culture since the Gilded Age. Artists use theater subjects to focus on social performances—on the stage, in the audience, or behind the scenes. The very real message of the performer's hard working life is given added resonance by the plangent presence of the sad clown, an evocative subject that regularly reappears in art across the centuries. Here, William Merritt Chase's jester (Pl. 15) is shown "keying up" by pouring himself a bracing back-stage drink before facing the footlights. When the large-scale version of this image was widely exhibited, it drew critical acclaim as "one of the most striking of recent American works, and from the genius that produced it the public have reason to expect much that will please" (1878). In choosing such a subject Chase signaled his awareness that artists themselves had become performers, increasingly dependent upon favorable criticism and a buying public.

Sloan strikes a more cheering, personal note in a canvas (Fig. 29) that also records how artists often adopt Bohemian ways to separate themselves from the bourgeois society that forms their chief audience. Sloan later recalled that the jolly company included "two pups, many hot dogs, and an old gray Ford," as well as a group of his artist friends "a couple of miles out on the North Road" near Santa Fe. Sloan's wife Dolly is seated on a blanket next to the fire, and Sloan himself sits to the right of Helen Shuster, another artist's wife, who stands with her arms theatrically raised. The convivial scene includes several of Sloan's students, a reminder that many American artists derived a steadier income from teaching than from sales of their work.

Difficulties in capturing a market share were to plague many later modernists, including both John Sloan and Walt Kuhn. Kuhn masks the difficulties of an artist's life behind the facade of a garishly costumed circus performer (Fig. 30). Her flattened treatment and harsh coloring suggest Kuhn's continuing interest in the aesthetic experiments of avant-garde European painters he helped bring to an unreceptive American public in the controversial Armory Show of 1913. Again recalling the sad clown, Kuhn pins his figure in a narrow vertical format and gives her an enigmatic expression. As she confronts the viewer directly, perhaps she bravely salutes the future of modernism in American art.

DPC

Plate 15 **William Merritt Chase** (1849–1916)
Keying Up (The Court Jester), circa 1875, oil
on panel, inscribed lower right: *W M Chase,* 15 x
8 ⅝ inches. The Warner Collection of Gulf States
Paper Corporation.

Figure 29 **John Sloan** (1871–1951)
Picnic on the Ridge, circa 1920, oil on canvas,
inscribed lower right: *John Sloan,* 26 ½ x 35 ⅜ inches.
The Warner Collection of Gulf States Paper
Corporation.

Figure 30 **Walt Kuhn** (1877–1949)
Salute, 1934, oil on canvas, 27 x 31 ⅞ inches.
Virginia Museum of Fine Arts Purchase,
The Adolph D. and Wilkins C. Williams Fund.

James McNeill Whistler
Corte del Paradiso

Subject, indeed, is not . . . lost; but rather absorbed by, or translated into the beauty of form—quite as the thought of a lyric poem becomes transfigured in its graceful garb of words.

—Ernest Fenollosa, 1907

Artists regularly employ the old in service of the new, and a painter may look to architecture and design as well as previous painting for stimulation. More than a century after Whistler wandered the quiet courtyards and back alleys of Venice, his exquisite pastels remain among the most eloquent testaments to the evanescent beauty of this often-painted city. While earlier artists, from Canaletto to Turner, chose the grandest palazzos and canals as subjects, Whistler sought out humble corners missed by crowds of tourists who flooded the Serenissima as regularly as did the tides of the Adriatic. With minimal strokes of color Whistler captured the atmosphere of a tiny courtyard off the Ruga Ciuffa, near a busy market square (Pl. 16). Laundry flutters festively over the heads of two strolling figures on the left. With a few strokes of his crumbly pastels, Whistler captured a woman holding a baby and peering from a doorway.

Always eager to stretch the artistic envelope, Whistler practiced advanced aestheticism, creating formal, almost abstract relationships of color and line. Narrative elements are supressed or hidden beneath glittering surface layers in what became popularly known as "art for art's sake." But Whistler reassured viewers accustomed to story-telling pictures by choosing something familiar—in this case, old Venetian buildings—as a departure point. The success of his method was manifest in the overwhelmingly positive critical response—not to mention brisk sales—that the pastels enjoyed when exhibited at the Fine Art Society upon Whistler's return to London.

A chair in the "anglo-japanese" taste (Fig. 31) by Whistler's friend, E. W. Godwin, incorporated details from ancient Japanese architecture to create a modern chair, featured at the Paris *Exposition Universelle* (1878). Part of a collaborative display of furniture and decoration created by Godwin and Whistler, the ensemble offered a sophisticated program of delicate color harmonies, not unlike Whistler's Venetian pastel.

Charles Sheeler also explored abstract formal relationships in his work, as is evident in *Hallway (Interior)* (Fig. 32). Yet like Whistler and Godwin before him, Sheeler controlled his experimental aesthetics by constructing a tectonic grid, whose foundation, ultimately, is architecture itself.

DPC

Plate 16 **James McNeill Whistler** (1834–1903) *Corte del Paradiso*, 1880, chalk and pastel on paper, inscribed lower edge center with butterfly monogram; inscribed lower right: *Corte del Paradiso*, 11 ½ x 5 ⅝ inches. The Warner Collection of Gulf States Paper Corporation.

Figure 31 **Edwin W. Godwin** (1833–1886) *Anglo-Japonesque Side Chair*, circa 1878, mahogany and cane, unmarked, 38 ³⁄₁₆ x 16 ⁵⁄₁₆ x 16 inches. Virginia Museum of Fine Arts, Gift of Mr. David K. E. Bruce, the Estate of Mrs. Edna Grumbach, Miss Elsie Murphy, John Barton Payne, Mrs. E. A. Rennolds in memory of Mr. and Mrs. John Kerr Branch, Mr. Raphael Stora, and Bequest of John C. and Florence S. Goddin; by exchange, with additional funds from The Arthur and Margaret Glasgow Fund.

Figure 32 **Charles Sheeler** (1883–1965) *Hallway (Interior)*, 1919, oil on canvas, inscribed lower right: *Charles Sheeler—1919*, 23 ¾ x 15 ⅞ inches. Private collection, photo courtesy of The Warner Collection of Gulf States Paper Corporation. (Not on view in exhibition.)

William Aiken Walker
Plantation Economy in the Old South

I pick up my life
And take it with me
And I put it down in
Chicago, Detroit, Buffalo, Scranton,
Any place that is North and East
And not Dixie.
—Langston Hughes, "One-Way Ticket," 1948

After Charleston-born William Aiken Walker served briefly in the Confederate army, he settled in Baltimore where he gained patronage—both southern and northern—for his paintings of rural life in the South. Over the next fifty years, the artist developed his characteristic repertoire of tattered but happy black folk. His picturesque imagery was in keeping with a postwar surge of nostalgia in art and literature for the antebellum plantation system.

When Walker completed *Plantation Economy in the Old South* in 1876 (Pl. 17), his retrospective view of an "Old South" plantation would have looked strikingly similar to then-current scenes of southern fields. On canvas, the painter catalogues the picking, bundling, milling, and transporting of cotton—all by African American laborers. Yet his romanticized portrayal conveys little of the unceasing, heavy, hot toil of harvesting and processing the deep South's primary cash crop. Though emancipated from slavery at the end of the Civil War, southern blacks became entrenched in a share-cropping system that flourished well into the next century. Men, women, and children worked cotton and other crops in return for housing, seed, and credit at the company store.

"King Cotton," monumentalized in Walker's later still life (Fig. 33), continued to flourish through the last decades of the 1800s. However, after the turn of the century, drought and the boll weevil all but devastated the southern crop. Fleeing the region's abject poverty and increased racial violence, African Americans migrated to the North in the tens of thousands. In an essay about the robust growth of the black community of Harlem in 1925, Alain Locke noted: "A railroad ticket and a suitcase, like a Bagdad carpet, transport the Negro peasant from the cotton-field and farm to the heart of the most complex urban civilization. Here in the mass, he must and does survive a jump of two generations in social economy and of a century and more in civilization."

Among the southern refugees were the parents of Jacob Lawrence. As a young artist who came of age in Harlem, Lawrence documented the Great Migration in a narrative series of paintings in 1941. Two years later, he captured the big-city bustle of urban African Americans—both long established and newly transplanted—in his painting, *Subway—Home from Work (Harlem Series #10)* (Fig. 34). ELO

Plate 17 **William Aiken Walker** (1838–1921) *Plantation Economy in the Old South,* circa 1876, oil on canvas, inscribed lower left: *W A Walker,* 22 x 42 inches. The Warner Collection of Gulf States Paper Corporation.

Figure 33 **William Aiken Walker** (1838–1921) *Cotton Plant and Blossoms,* circa 1880, oil on canvas, inscribed lower right: *W A Walker,* 20 x 12 ¼ inches. The Warner Collection of Gulf States Paper Corporation.

Figure 34 **Jacob Lawrence** (born 1917) *Subway—Home From Work (Harlem Series #10),* 1943, watercolor on paper, inscribed lower right center on mat: *J. Lawrence,* 14 x 21 ¼ inches. Virginia Museum of Fine Arts, Gift of the Alexander Shilling Fund.

John Singer Sargent
Capri

Say what ill of it you may; [Italy] still remains to the poet the land of his predilection, to the artist the land of his necessity, and to all the land of dreams and visions of delight.

—Henry Wadsworth Longfellow, 1851

Italy has been an important destination for northern artists since the Flemish painter Rogier van der Weyden crossed the Alps in the fifteenth century. By the time Americans began traveling there in the nineteenth century, the marked contrast between their new republic and the ancient cradle of civilization made their Italian sojourns especially meaningful.

Sargent was only twenty-two years of age when he visited Naples and the island of Capri late in the summer of 1878. He wrote to a friend that the heat made him feel "generally . . . used up," yet in Italy he found "all that one can dream for beauty and charm." Rendered in sherbety tones that have lost none of their refreshing tang, Sargent's vision of a young girl dancing the tarantella (Pl. 18) may recall a fête he organized on the roof of his hotel to entertain other foreign painters working on the island. Here, the model, a favorite with artists on Capri, twirls gracefully, accompanied by the rhythms of a tambourine played by her companion. The broad sweep of white plaster and the distance between the viewer and the performance reinforce Sargent's own status as an observant yet detached wanderer, one who gathered memorable impressions of foreign locales as if he were a permanent tourist.

Sargent's vision of Capri presages an elegant series of peasant girls that he would paint in Venice a few years later. Again, he exercised detachment from the actual lives of the people he observed. Venice had become, for American expatriates, a city of ghosts, her stones more significant than her living occupants, who could be ignored or hired as colorfully dressed extras for costume pieces. "In Venice, where everything has its own way of becoming beautiful, dirt, at the right distance, gives fine tone to an old face," noted Arthur Symons in 1907.

The lure of Italy had not faded at the end of the century, when Maurice Prendergast took delight in the festive atmosphere of a Venetian square during a trip in 1898 (Fig. 35). And the objects represented in a still life painted in Rome by Charles Caryl Coleman remind us that some expatriates gathered more than visual memories (Fig. 36). Both at home and abroad, Americans found that the arts of other countries were instructive in developing a personal aesthetic linked to the great movements of the past. In filling his studio with the decorative arts of foreign cultures, Coleman confirmed the historian Henry Tuckerman's adage in *The Book of the Artists* (1867) that, for Americans, the "enchantment of distance" kindled rich associations.

DPC

Plate 18 **John Singer Sargent** (1856–1925) *Capri,* 1878, oil on canvas, inscribed lower left: *to my friend Fanny/ John S. Sargent;* inscribed lower right: *Capri 1878,* 20 x 25 inches. The Warner Collection of Gulf States Paper Corporation.

Figure 35 **Maurice Prendergast** (1859–1923) *Campo Santa Maria Formosa, Venice,* circa 1898, watercolor on paper, inscribed lower left: *Maurice Prendergast,* 12 ⅝ x 18 ½ inches. The Warner Collection of Gulf States Paper Corporation.

Figure 36 **Charles Caryl Coleman** (1840–1928) *Quince Blossoms,* 1878, oil on canvas, monogram, middle right: *Roma 1878/ CCC,* 31 ¾ x 43 ⅝ inches. Virginia Museum of Fine Arts Purchase, The J. Harwood and Louise B. Cochrane Fund for American Art.

Frank Duveneck
Miss Blood

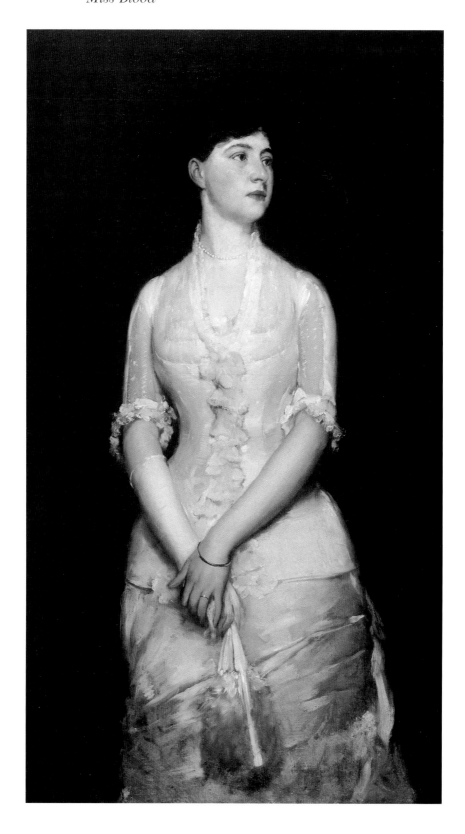

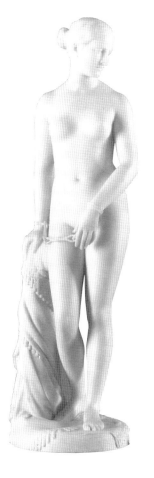

[Christopher Newman shopped for]
the best article on the market . . .
a beautiful woman perched . . .
like a statue on a monument
[to his own success].

—Henry James, *The American*, 1877

A portrait can convey far more than the likeness of a sitter. Miss Blood's aloof countenance masks layers of social precedent and change, even though we cannot discern the sordid details (Pl. 19). Gertrude Blood was a socialite from London who pursued Frank Duveneck through their mutual association with a sketching club in Venice. Though she tried to advance his career, she didn't manage to capture him. By the time Duveneck painted her, she was already engaged to marry Lord Colin Campbell, an alliance that would eventually end in divorce. Divorced women were as controversial as stylistically advanced painters who hoped to break the bonds of traditional painting by exchanging broadly brushed subjects from modern life for the tightly finished, trite themes of academic art. With its elegant tonal harmony and vigorously brushed surface, this portrait would have appeared starkly contemporary to viewers in 1880. But artists regularly seek reassurance for their own choices by looking at earlier art. Clearly Duveneck admired the seventeenth-century Spanish painter, Velázquez, as well as the much discussed series of women in white by Whistler (1870s), another American expatriate artist working in Venice when Duveneck was there.

Duveneck's picture also addresses fashion and decorum. Miss Blood's regal posture is noticeably shaped by tight corseting that, as one costume historian notes, played "a major supporting role in the life of Victorian women." The conventionally demure sitter has her hands crossed, and the artist's reduced color scheme lends special prominence to a gold bracelet she wears on her left wrist. Her pose recalls that of Hiram Powers's *Greek Slave*, a shackled figure that achieved unprecedented fame in American art after the sculpture was exhibited at the Crystal Palace in London (1851). "So un-dressed yet so refined," was Henry James's verdict on the nude white marble, which was celebrated in amateur and professional poems, not to mention endless replications including this one (Fig. 37).

While not exactly up for auction, Miss Blood is imprisoned in a stylish dress that expresses established conceptions of women's limited roles, just as painters were hemmed in by traditional ideas of how a picture should be painted or what it might legitimately represent. "It is . . . undeniably the truth that from the age of eighteen until she is either married or shelved a girl is on exhibition," complained one writer in 1880, the year Duveneck painted the portrait.

As conventional manners and decorum gave way, artists like Robert Henri brushed vigorous canvases such as the *Spanish Girl of Madrid* (Fig. 38). The vivacious model looks out with a pert and confident gaze, her hands on hips, her fan folded. Henri painted the reds and blacks of her costume lavishly, in bold, free brushstrokes that energize the life-size image. He too was taken with Velázquez, finding the Spaniard's art "simple and direct." But, as we see in all the artworks reproduced here, the choices an artist makes are usually complex.　　　　DPC

Plate 19　**Frank Duveneck** (1848–1919)
Miss Blood, 1880, oil on canvas, inscribed upper left: *FD*; upper right: *Venice 1880*, 48 x 28 inches. The Warner Collection of Gulf States Paper Corporation.

Figure 37　**Hiram Powers** (1805–1873)
The Greek Slave, 1873-77, marble, inscribed on base: *H. Powers Sculp.*, 46 inches high. The Warner Collection of Gulf States Paper Corporation.

Figure 38　**Robert Henri** (1865–1929)
Spanish Girl of Madrid (Una Chula), 1908, oil on canvas, inscribed on verso: *Una Chula and E186*, 60 x 40 inches. Virginia Museum of Fine Arts Purchase, The J. Harwood and Louise B. Cochrane Fund for American Art.

John Frederick Peto
Still Life with Oranges and Banana

The arrangement of fresh fruits for the table affords play for the most cultivated taste and not a little real inventive genius. . . . a raised center-piece of mixed fruits furnishes a delicious dessert and is an indispensable ornament to an elegant dinner-table.

—*Practical Housekeeping*, 1884

Through sight—and imaginary touch, smell, and taste—we partake of the ripe fruit in John Frederick Peto's *Still Life with Oranges and Banana* (Pl. 20). Following long-established trompe l'oeil conventions, the artist pushes the brightly lit arrangement to the front edge of the table and picture plane. Peto explores the sensuous shapes of the fruit, all richly textured and glowing against a velvety dark background. One orange still shows the remnants of its white tissue-paper wrapping; the other has been peeled and opened for our enjoyment.

Peto, who studied art in Philadelphia, continued in the American still-life tradition of the Peale family, Severin Roesen, and William Harnett. At mid century, his predecessor Roesen gained popular acclaim for such elaborate still-life paintings as *Abundance of Fruit* (Fig. 39). The immense display piece, with its two-tiered inventory of almost every domestic fruit available around 1860, represents the optimistic vision of pre–Civil War Americans who

saw themselves as beneficiaries of God's blessings in the New World. The sentiment is echoed in the ebullient ornamentation on a sofa by John Henry Belter (Fig. 40). Exhibiting a similar Victorian design penchant for filling empty space, Belter lavished every inch of the gilded rosewood supports with cornucopias spilling forth flowers, nuts, and fruit.

Peto's small painting, on the other hand, is simple in its composition and exhibits the softer, more painterly characteristics of 1880s aestheticism. Although it does not offer the riotous celebration of abundance found in a Roesen painting or Belter sofa, it speaks of prosperity in quieter ways. The artist, having relocated to Island Heights, New Jersey, in the 1880s, sold his trompe l'oeil still lifes to genteel urban families who summered at that seaside resort. His Gilded Age clientele enjoyed the material and economic fruits of an American market economy fueled by burgeoning industry and commerce. And they could afford the more expensive tropical fruits—like oranges and bananas—that were hastened from Florida, the Caribbean, and South America by new transcontinental railways to their elegantly appointed dinner tables. ELO

Plate 20 **John Frederick Peto** (1854–1907) *Still Life with Oranges and Banana*, circa 1880, oil on panel, unsigned, 5 x 10 inches. The Warner Collection of Gulf States Paper Corporation.

Figure 39 **Severin Roesen** (act. 1848–1871) *The Abundance of Fruit*, circa 1860, oil on canvas, inscribed lower right: S Roesen, 36 x 50 ¼. The Warner Collection of Gulf States Paper Corporation.

Figure 40 **John Henry Belter** (1840–1863) *Sofa*, circa 1850, 43 x 94 x 36 ½ inches. Virginia Museum of Fine Arts, Gift of Mrs. Hamilton Farnham Morrison in memory of her parents, Robert Letcher Moore and Josephine Landes Moore.

Theodore Robinson
Winter, Giverny

[The Impressionist] is a realist, believing that nature and our own day give us abundant and beautiful material for pictures: that, rightly seen and rendered, there is as much charm in . . . a landscape of sunlit meadows or a river-bank, as the . . . "classical landscape"; that there is an abundance of poetry outside of swamps, twilights, or weeping damosels. M. Claude Monet's work proves . . . that there is no antagonism between broad daylight and modernity, and sentiment and charm.

—Theodore Robinson, 1891

By the 1870s, Impressionism had emerged as a recognized alternative to the classical painting of the French Academy. It exchanged shadows for sunlight, the interior for the outdoors, historic subjects for daily life, studied composition for spontaneous vision, and an invisible application of muted color for evident multicolored strokes. From the late 1880s Impressionism engaged many American painters. Yet they were selective in their appropriation of these unfamiliar stylistic techniques, and they felt free to combine them with earlier modes of painting, creating their own essentially positivist vision quite consciously removed from the social upheavals taking place in late nineteenth-century Europe.

Theodore Robinson's *Winter, Giverny* (Pl. 21) numbers among the earliest efforts by Americans to incorporate new French ideas into their work. Robinson studied in Paris with Emile Carolus-Duran and Jean-Léon Gérôme, but by 1887 he had traveled to Giverny to work near Claude Monet. Monet's mode of painting *en plein air*—out of doors— encouraged Robinson to experiment with effects of light and atmosphere. Although he was working on a seemingly spontaneous sketch, Robinson did not entirely abandon his previous training. In particular, his composition is made up of balanced solids and voids, in keeping with the tenets of academic training.

Like Robinson, John Leslie Breck traveled to Giverny in 1887 to work alongside Monet. Again like Robinson, his paintings retain academic elements. After returning to Boston in 1890, Breck associated with a group of local Impressionists. His works from this period, such as *Grey Day on the Charles* (Fig. 41), rely on a blend of freely brushed passages and highly keyed color to render an image whose detail is never greatly suppressed. Despite the freewheeling example of French Impressionist painters, American artists were unwilling to give up the sense of drawing that undergirds their work. Here, Breck's receding perspective directs the eye across a well-balanced vista constructed in the manner of academic painting.

By the time of Breck's death, an established group of young Boston figurative painters, including Joseph DeCamp, further modified the lessons of French Impressionism. DeCamp's *Summer Landscape* (Fig. 42) eloquently expresses the preference of a new generation of American painters for modest, out-of-the-way rural sites, far removed from the grandiose panoramas of mid nineteenth-century American landscape painting. Like Breck, DeCamp offers us a carefully orchestrated studio image, not a spontaneous outdoor sketch. And both artists chose subjects that completely avoided the issue of industrial incursions on the landscape. The banks of the Charles River were being built up a mere fifteen miles from the site Breck chose to paint. And DeCamp, by showing us an old stone fence in tumble-down condition, hints at the nostalgia for supposedly simpler times—a sentiment shared by many Americans as their nation continued its ascension to world power.

SJR

Plate 21 **Theodore Robinson** (1852–1896) ***Winter, Giverny,*** 1889, oil on panel, inscribed lower right: *Giverny 9 Dec. 89,* 10 1/4 x 13 3/4 inches. The Warner Collection of Gulf States Paper Corporation.

Figure 41 **John Leslie Breck** (1860–1899) ***Grey Day on the Charles,*** 1894, oil on canvas, inscribed lower right: *John Leslie Breck—1894—,* 18 x 22 inches. Virginia Museum of Fine Arts Purchase, The J. Harwood and Louise B. Cochrane Fund for American Art.

Figure 42 **Joseph R. DeCamp** (1858–1923) ***Summer Landscape,*** undated, oil on canvas, inscribed lower right: *Joseph DeCamp,* 20 x 27 inches. The Warner Collection of Gulf States Paper Corporation.

Childe Hassam
Celia Thaxter's Garden

One blossom . . . breathes a glory of color into sense and spirit which is enough to kindle the dullest imagination.

—Celia Thaxter, *An Island Garden*, 1894

An enticing glimpse of wooden stairs and a wild garden (Pl. 22) relate to Childe Hassam's sensitive images for *An Island Garden,* published by the poet Celia Laighton Thaxter in 1894. The garden grew on Appledore, one of the Isles of Shoals—a group of granite outcroppings ten miles off the coast of New Hampshire, near Portsmouth. A lighthouse keeper's daughter, Thaxter served as an aesthetic beacon, attracting nineteenth-century artists, writers, and musicians up these steps to her flower-filled parlor.

On the seemingly inhospitable rocks of Appledore, the imagination could flourish like the flowers in Thaxter's garden. Inspired by impressions of the parlor's cultured atmosphere, the garden's brilliant color, and the landscape's wild beauty, Hassam executed some of his most successful works at the Isles of Shoals. There he conducted periodic summer painting campaigns from the mid 1880s well into the twentieth century. His finest Shoals images, created between 1889 and 1912, coincide with the full flowering of Hassam's powers as a painter.

In this picture, one can barely discern a figure leaning against the rail on Thaxter's porch, shaded by the leaves of hops. Hollyhocks wave majestically in the garden. Such old-fashioned plants—"the flowers our grandmothers loved," as Thaxter herself put it—were ever more popular at the end of the nineteenth century, when the woes of industrialization prompted desire for leisure time spent far away from crowded urban streets. Like the blossoms in a herbaceous border captured by John Singer Sargent in his *Corner of a Garden* (Fig. 43), Hassam's tangled summer annuals signal nostalgia for "the good old days," a widespread sentiment in American culture at the turn of the twentieth century.

Journalists encouraged tourists to visit the Shoals. *Harper's Monthly* (October 1874) told readers that "the glory of these islands is . . . in the rocks themselves . . . for their soft grays and browns wed very happily with the scanty grass and foliage, and bring forth exquisite effects of color." Such colors are featured in another Shoals picture by Hassam (Fig. 44). Seascapes dominated his output at the Shoals from 1899 until he stopped coming around 1916. Two years earlier, a raging fire swept most of the buildings, including the hotel, Celia Thaxter's parlor, and Hassam's little studio, from their seemingly firm foundations. The sudden obliteration of the Appledore resort serves as a harsh reminder of man's rather tenuous hold on these glacier-scarred granite domes. Before that, however, Thaxter helped Hassam see beyond "mere heaps of tumbling granite." For both poet and painter, the infinitely aged Isles of Shoals were precious stones set in a silver sea, "musical with birds, and with the continual caressing of summer waves."

Plate 22 **Childe Hassam** (1859–1935) *Celia Thaxter's Garden,* circa 1890, oil on canvas, inscribed lower left: *Childe Hassam,* 13 x 9 7/16 inches. The Warner Collection of Gulf States Paper Corporation.

Figure 43 **John Singer Sargent** (1856–1925) *Corner of a Garden,* circa 1910, oil on cradled panel, inscribed lower left: *to my friend . . . John S. Sargent,* 14 x 10 inches. The Warner Collection of Gulf States Paper Corporation.

Figure 44 **Childe Hassam** (1859–1935) *The Isle of Shoals,* 1912, oil on canvas, inscribed right edge center: *Childe Hassam/ 1912,* 22 x 18 inches. Virginia Museum of Fine Arts Purchase, The Adolph D. and Wilkins C. Williams Fund.

DPC

William Merritt Chase
Young Girl on Ocean Steamer

"Keep, ancient lands, your storied pomp!" cries she
With silent lips, "Give me your tired, your poor,
Your huddled masses yearning to breathe free . . ."
— Emma Lazarus, *The New Colossus*, 1883

The Statue of Liberty, created by French sculptor Frederic August Bartholdi, was nearly ready to be shipped from Paris to New York when Emma Lazarus wrote her now-famous sonnet about the monument as part of a fund-raising effort to build an appropriate architectural base for it in New York Harbor.

The following year, William Merritt Chase was traveling back from Holland, where he had been visiting his friend Robert Blum. During the trip, Chase drew one of his most elegant pastels, showing a young girl seated on a stool in the first-class salon aboard a trans-Atlantic steamer (Pl. 23). Scattered behind her on a white tablecloth are lovingly rendered bits of silver and china. These remnants of an elegant dining experience might serve to remind us how Chase, who loved the "storied pomp" of old Europe and did not want to leave it behind, filled his New York studio with European art and artifacts to associate his own career with the great masters of previous centuries.

In 1886, the Statue of Liberty was finally unveiled. At the time, the stern colossus was actually intended to commemorate international friendship between France and the United States. The same year also witnessed Chase's first one-artist exhibition, and among the pieces he selected for display at the Boston Art Club was *Young Girl on an Ocean Steamer.* One might see Chase's pastel as an elegant testament to the friendly reception of modern French painting—particularly the work of Edgar Degas—by young American painters, including not only Chase, but also Mary Cassatt, who worked directly with the Frenchman.

Chase's little model, in her brick-red dress and black stockings, holds an orange—a vivid spark of color that centers the composition. She is a model of gentility; and the pastel itself, of aesthetic beauty. Similarly, Cassatt's gentle pastel, *The Banjo Lesson,* uses a cool blue-green color harmony to capture a young woman playing the instrument as her sister hovers, like a grace note, at her shoulder (Fig. 45).

Brighter and brasher in both costume and decorum is the little girl who whispers to her companion *In the Corner* (Fig. 46). George Luks was noted for uncompromising figures of "prize-fighters, drunkards, wrestlers, beggars, cabbies, old women, guttersnipes, street dancers, pushcart peddlers, bartenders" painted in "high reeking colors." This self-consciously virile language, typical of the way journalists described Luks's work, revealed a sea change in artistic thinking in America. In brief, the aestheticism and concentration on beauty by American Impressionists gradually gave way to harsher, darker urban scenes by American Realist painters who were responding to circumstances that resulted in part from increased immigration.

But Luks has set these children in an art gallery. The heavy frame of an oil painting can just be made out behind them. Not nearly so well off economically as the child on the ocean steamer, who has had the advantage of European travel, these urban dwellers are dependent upon public museums for their exposure to "the storied pomp" of the "ancient lands" they and their families had left behind for the greater opportunities America afforded.

Interestingly, the Statue of Liberty, while stern, is a nurturing, feminine image. While the stream of "huddled masses" to America's shores raised alarm in some quarters, spurring strong opposition toward unrestricted immigration, the idealized conception of America as a refuge from European oppression remained a fundamental American value. Public art museums were seen as one path by which newly arrived Americans could be acculturated to their new surroundings. In effect, works of art, like Liberty herself, lift their lamps beside the golden door. DPC

Plate 23 **William Merritt Chase** (1849–1916)
Young Girl on an Ocean Steamer, circa 1884, pastel on paper, inscribed right edge center: *Wm M Chase,* 29 x 24 inches. The Warner Collection of Gulf States Paper Corporation.

Figure 45 **Mary Cassatt** (1844–1926)
The Banjo Lesson, 1894, pastel on paper, inscribed lower right: *Mary Cassatt,* 28 x 22 1/2 inches. The Virginia Museum of Fine Arts Purchase, The Adolph D. and Wilkins C. Williams Fund.

Figure 46 **George Luks** (1866–1933)
In the Corner, 1920–21, oil on panel, inscribed lower right: *george luks,* 48 x 37 inches. The Warner Collection of Gulf States Paper Corporation.

George de Forest Brush
The Shield Maker

Then the noble Hiawatha
Took his soul, his ghost, his shadow,
Spake and said: "O Pau-Puk-Keewis . . . ,
I will change you to an eagle,
To Keneu, the great war-eagle. . . .
— Henry Wadsworth Longfellow, *The Song of Hiawatha*, 1885

Between 1881 and 1885, George de Forest Brush traveled the American West, study-ing the Crow, Shoshone, and Arapaho peoples of Montana and Wyoming and creating some of the most sensitive images of Native Americans and their culture ever produced by an American artist. Brush himself commented in 1885, "In choosing Indians as sub-jects for art, I do not paint from the historian's or the antiquary's point of view; I did not care to represent them in any curious habits which could not be comprehended by us; I am interested in those habits and deeds in which we have feelings in common."

Here, however, despite his sympathetic words, Brush could not resist objectifying his chosen subject, using the rich color, contrasted texture and overt realism of academic classicism to create a sort of exotic American still life out of the "wild man and wild beast and bird" celebrated in Ralph Waldo Emerson's 1844 essay, "Experience." The Indian, the jaguar, and the flamingo are all beautiful New World fauna to Brush, and all of them were disappearing. Jaguars that once roamed the American Southwest had been driven far into Central and South America by advancing civilization; similar forces threatened the flamingo almost to the point of extinction, as suggested by George Catlin's picture of hunters slaughtering the brightly feathered birds for commercial purposes (Fig. 47). Clearly, Native Americans had suffered parallel encroachments.

Somewhat hardier is the metaphorical use of the eagle as an inspiring icon by Americans of all backgrounds. In the same year that Lewis and Clark set foot on the Pacific in their search for trading routes, Samuel McIntire produced this regal bird (Fig. 48) for an eastern clientele made up largely of Salem merchants. Its wings are spread in an all-embracing gesture while its gilt surface glitters with the promise of individual opportunity

SJR

Plate 24 **George de Forest Brush** (1855–1941) ***The Shield Maker***, 1890, oil on canvas, inscribed lower left: *Geo de F Brush 1890*, 11 x 16 inches. The Warner Collection of Gulf States Paper Corporation.

Figure 47 **George Catlin** (1796–1872) ***Shooting Flamingoes, Grand Seline, Buenos Aires***, 1856, oil on canvas, inscribed bottom center: *Catlin*, 18 ½ x 25 ¾ inches. Virginia Museum of Fine Arts, The Paul Mellon Collection.

Figure 48 **Samuel McIntire** (1757–1811) ***Eagle***, 1804–5, gilded wood, 15 ½ inches high. The Warner Collection of Gulf States Paper Corporation.

Robert Blum
The Picture Book

The magnificent Japanese display at the Centennial Exhibition, in 1876, augmented the wild desire that had grown up in me to some day visit this country of art.

— Robert Blum, *Scribner's Magazine*, April 1893

The kimono-clad reader in Robert Blum's tiny but intense image (Pl. 25) contemplates an art book with the same concentration that Blum himself brought to his long-desired travels in Japan. As early as 1873, Blum's fascination with Asian art was kindled by the purchase of a Japanese fan from a street vendor. Then, in 1876, the young artist encountered the elaborate Japanese Pavilion at the Centennial Exposition in Philadelphia, an experience that fixed the arts of Japan in many an American mind. A student of Frank Duveneck, Blum managed multiple trips to Europe in the 1870s and 1880s. Joining his teacher in Venice, Blum met James McNeill Whistler and was intrigued by the older artist's use of design principles based on Japanese prints. Although he never actually traveled in Asia, Whistler eventually applied eastern ideas of color and composition to thoroughly western subjects, such as *Harmony in Blue and Pearl: The Sands, Dieppe* (Fig. 49).

 Direct experience of the Far East eluded Blum until 1889, when he secured a commission from *Scribner's* to create pastels and drawings for Sir Edwin Arnold's *Japonica*, which was serialized in the magazine. The commission allowed Blum to live in Japan for two and a half years, creating drawings and pastels as well as a few rare oils. His detailed view of a temple in Tokyo reveals Blum's careful scrutiny of the art, architecture, and religion of Japan (Fig. 50). His canvas accurately records the temple's lavish carved and painted decorations, the white costume and straw hat of a Buddhist pilgrim, and evidence of religious activity: the triangular bamboo stand used to leave offerings of food for the monks, the gongs rung with twisted ropes to summon the gods, and the brazier from which rises the smoke of sacrificial incense sticks. At the same time, he also includes more prosaic details such as chickens scratching in the forecourt.

 While this picture reveals an American eagerness for information about the "mysterious East" during the final decades of the nineteenth century, Blum's young girl reading seems to float in a neutral setting. In homage to both beauty and study, she addresses a more contemplative aspect of the artistic imagination—Japan as a "country of art." The pages of her open book evoke not only Blum's fascination with things Japanese, but also the important role played by Japanese prints in transmitting eastern aesthetic concepts to western artists, whether they had the opportunity to travel in Japan or not. DPC

Plate 25 **Robert Blum** (1857–1903)
The Picture Book, circa 1890, oil on panel, unsigned, 6 ½ x 9 ¾ inches. The Warner Collection of Gulf States Paper Corporation.

Figure 49 **James McNeill Whistler** (1834–1903)
Harmony in Blue and Pearl: The Sands, Dieppe, circa 1885, oil on panel, inscribed lower right: *butterfly monogram*, 9 x 5 ½ inches. The Warner Collection of Gulf States Paper Corporation.

Figure 50 **Robert Blum** (1857–1903)
The Temple Court of Fudo Sama at Meguro, Tokyo, 1891, oil on canvas, inscribed lower right: *Blum*, 27 x 9 ⅞ inches. Virginia Museum of Fine Arts Purchase, The J. Harwood and Louise B. Cochrane Fund for American Art.

Albert Herter
The Family Group

No country seems to owe more to its women than America does nor to owe them so much of what is best in social institutions and in the beliefs that govern conduct.

<div align="right">— James Bryce, The American Commonwealth, 1889</div>

Albert Herter belonged to a family of artists and craftsmen whose work graced the homes of America's well-to-do from the middle of the nineteenth century. Such patrons were at once fashionable and old-fashioned: desirous that their homes display the latest style, they supported the skills of immigrant cabinetmakers; but they wore Parisian gowns that were two years old so as not to appear too forward in dress. If they were generals in the revolutions of industry and finance, they were nonetheless privates in an army called *Taste*.

The Family Group (Pl. 26), by Albert Herter, uses a brightly colored, richly textured image to touch on some of the chief concerns of the Aesthetic Movement. An emphasis on feminine domesticity and an engagement with bold patterning govern this depiction of five females in a garden. Their naturalistically rendered faces are juxtaposed with the same type of elaborate repeating decoration inlaid on a center table designed by Christian Herter, Albert's uncle. In the detail shown here (Fig. 51), flat simple flowers, leaves, and berries dominate; they are drawn from a variety of Near and Far Eastern sources. Like the Herter watercolor, the table produces an overall effect of floral splendor.

In Herter's picture, the figures clearly vary in age. All of them glance away from the viewer, except for the youngest child, who looks straight out. Rigid middle- and upper-class social codes dictated that a woman's place was with her family. As the switch from an agrarian to an industrial economy absorbed men into the urban work place, the home was cast as a haven from the outside world. *The Book of Woman's Power* (1908) asserted, "She may set herself to train up each generation to be worthier than the last, and may make each home in some sense a heaven of peace on earth." Under the instruction of their mothers, children were permitted to experience a youthful innocence which ended soon enough. As Herter's image shows us, older girls were expected to behave like their elders.

Mary Cassatt's *Denise and Child* (Fig. 52) makes a more subtle nod to domesticity, calling on old master images of the Madonna and Christ Child to invest her picture with a timelessness that the fashionable Herter image lacks. But she, too, incorporates elements of the Aesthetic Movement—notably the sunflower, a symbol of renewal and enlightenment, and a green and yellow color scheme that derives ultimately from the "greenery-yallery" interiors of Aesthetic Movement households of the 1880s. Cassatt, like Herter, concentrates on females, and again, emphasizes youth. Each image, and the table too, for that matter, asserts a comforting balance of modernity and tradition at the turn of the twentieth century. SJR

Plate 26 **Albert Herter** (1871–1950)
The Family Group, circa 1898, watercolor and gouache on paper, inscribed lower right: *Albert Herter,* 15 x 11 ½ inches. The Warner Collection of Gulf States Paper Corporation.

Figure 51 **Herter Brothers** (active 1857–1900)
Aesthetic Movement Center Table (detail), 1877–78, ebonized maple, parcel gilt, gilt-bronze, stamped on stretcher: *Herter Brothers,* 30 ¾ x 56 x 35 inches. Virginia Museum of Fine Arts Purchase, The Adolph D. and Wilkins C. Williams Fund.

Figure 52 **Mary Cassatt** (1844–1926)
Denise and Child, circa 1905, oil on canvas, inscribed lower right: *Mary Cassatt,* 39 ½ x 29 inches. The Warner Collection of Gulf States Paper Corporation.

Daniel Garber
Tanis

I'm interested in the less obvious, in the more suggestive and subtle side of things. I suppose it's the dream mood of the thing that gets me.

—Daniel Garber, 1922

At the turn of the twentieth century, Henry Adams coined a telling metaphor—the dynamo and the Virgin—to express twin forces of present and past operating in a rapidly changing modern society. Adams wrote, "The dynamo became a symbol of infinity. As [I] grew accustomed to the great gallery of machines, [I] began to feel the forty-foot dynamos as a moral force, much as the early Christians felt the Cross."

Framed in a doorway and backlit by brilliant light, Daniel Garber's daughter stands, a secular virgin lost in thought (Pl. 27). A sunshine halo crowns her blond head, and the light filters through her thin white smock to reveal a lissome form as slender as the newly leafed trees behind her. In her bare feet, Tanis comfortably transverses the boundary between exterior and interior realms. Garber's painting lovingly captures the naturalness of girlhood before the onset of adolescent and adult self-conscciouness. Her momentary reverie at the open door invites the viewer to revisit childhood dreams of unlimited possibilities.

Painted in 1915, Garber's child is poised quite literally on a social and political threshold. She will soon grow into a young woman, like the debutante seen in Edmund C. Tarbell's *After the Ball* (Fig. 53). The economic turmoil of the late nineteenth and early twentieth centuries fostered a gradual expansion of opportunities for women. Yet change was slow in coming. It can be argued that Bostonian painters like Tarbell objectified women, reducing them to precious ornaments in luxurious surroundings— here his debutante, in virginal white, slumps in an armchair, her gloves tossed aside, her bouquet already beginning to wilt. Would this be the fate of Garber's daughter as well? She, at least, would see women granted the right to vote in 1920.

Stylistically, Garber's work managed to blend a bright Impressionist palette with the solid modeling of earlier academic art. "Form is the natural philosophy of art, as color is its drama, and when philosophy of form is combined with a tonal use of the palette, it achieves an elusive though quiet poetry," wrote a journalist reviewing Garber's work in 1922.

Tradition is regularly synthesized with innovation in all branches of American art. An elaborate brass and ceramic plant stand (Fig. 54) made in Meriden, Connecticut, is as brightly colored as Garber's painting. Popular in the 1880s, such objects were considered "art furniture." The plant stand is embellished with an international array of ornament from the past, including Egyptian geometries stamped into the brass. We might see this machined product as both a mechanistic dynamo, symbolic of America's rising industrial might, and a medieval column, recalling the spiritual cult of the Virgin. Similarly, Garber addressed his modern subject through a traditional format: the large-scale academic salon portrait.

Garber called his daughter Tanis, a Lithuanian surname derived from Athanasius, which means immortal. Was he also aware of the ancient city of Tanis, in the Nile Delta, excavated by British explorer Flinders Petrie in the 1880s at about the time the plant stand was made? Among the immortal treasures discovered at the site were a colossal statue of Ramses II as a child protected by the Canaanite falcon-god Huron and two red granite sphinxes from the Middle Kingdom.

As Homer Saint Gaudens noted in 1941, Garber "does not paint a sugary picture but a picture that is fortunate to contemplate." We cannot tell what will happen to Tanis. Will she prove a dynamo, a new woman liberated by the opportunities of life in the twentieth century? Our interpretation must remain open ended. We cannot know either her thoughts or her prospects. On the subject of his daughter's daydream Garber remains silent as a sphinx.

DPC

Plate 27 **Daniel Garber** (1880–1958)
Tanis, 1915, oil on canvas, inscribed lower left: *Daniel Garber*, 60 x 46 ¼ inches. The Warner Collection of Gulf States Paper Corporation.

Figure 53 **Edmund C. Tarbell** (1862–1938)
After the Ball, circa 1890, oil on canvas, inscribed lower left: *Edmund C. Tarbell*, 28 x 32 ¼ inches. The Warner Collection of Gulf States Paper Corporation.

Figure 54 **Unknown manufacturer (probably Meriden, Connecticut)**
Stand, circa 1880–85 cast brass, painted and glazed earthenware, tile stamped: *Japonaise No. 3*, 32 ½ x 14 ¾ x 14 ¾ inches. Virginia Museum of Fine Arts Purchase with Funds Provided by an Anonymous Donor.

Edward Lamson Henry
Colonial Wedding

[T]here are few American artists who have better served their country in preserving for the future the quaint and provincial aspects of a life which has all but disappeared since we have become the melting pot for other races than our own.

—Will Low, *Evening Post*, 1919

Following the Centennial celebrations of 1876, Americans became increasingly aware of their historical past. With each succeeding decade, through the 1930s, interest in the seventeenth and eighteenth centuries grew in intensity. Buyers scrambled to acquire surviving colonial buildings and antiquities. Writers, musicians, architects, and artists tried to recreate popular motifs of earlier days. Entrepreneurs like Wallace Nutting—historian, photographer, and designer—helped popularize the colonial aesthetic by reproducing the "best" examples of historic furnishings to grace and uplift American homes (Fig. 55). The retrospective movement was fueled by growing nationalism, responses to modernization, and reactions to an increasing influx of immigrants. During this period of intense social change, it helped solidify a strong white, Anglo-Saxon, Protestant national identity.

Few artists embraced the Colonial Revival more than Edward Lamson Henry. A passionate collector, he amassed an assortment of antiquities, costumes, carriages, and salvaged building parts—many of which he reproduced in his genre paintings (depictions of everyday life). The artist also gathered bits of local history and folklore, some of it becoming themes for his nostalgic imagery. In her memoirs, Henry's widow relates that the inspiration for *Colonial Wedding* (Pl. 28) came from her grandmother's tales of her own wedding day. After that long-ago ceremony and dinner on the grounds of the family's New York estate, the newlyweds took their leave by horseback. "In that early time," Mrs. Henry wrote, "there were few carriages in the country, and the wedding journey . . . was taken on a pillion behind grandfather's back, she holding on with her arms around his waist. A little horsehair trunk was strapped on the pack horse to follow."

On canvas, Henry reconstructed the general details of the story. However, he shifted the scene to seventeenth-century Virginia in order to craft a more elaborate narrative that includes visiting English officers and Native American dignitaries. The nuptial celebration acquires the romantic and moral overtones of Thanksgiving. Settlers, soldiers, and Indians mingle happily; their weapons lay stacked together at right. The altered setting also afforded the painter an opportunity to portray his beloved artifacts. According to his wife, he was initially stumped in his attempts to find a pillion. After finally locating and sketching one at the Smithsonian Institution in Washington, D.C., the artist only hinted at the bride's unusual platform seat behind the saddle.

The successful career of sculptor Daniel Chester French also coincided with the Colonial Revival movement and was marked by a series of representations of American patriots and statesmen. Born to an old New England family, French gained early acclaim for his first important commission, a tribute to the Revolutionary War *Minute Man* (Concord, Massachusetts, 1873). At the turn of the century, the veteran sculptor collaborated with Edward C. Potter to produce a heroic, life-sized equestrian sculpture of *George Washington* for the Place d'Iena, Paris (Fig. 56, one of four casts of the working model). French's final and best-known commission, the seated *Lincoln* in the Lincoln Memorial (Washington, D.C., 1916), became an American icon. In each of these sculptures, French's selective vision ensured that certain idealized American heroes remained firmly in the public consciousness.

ELO

Plate 28 **Edward Lamson Henry** (1841–1919) *Colonial Wedding,* 1911, oil on canvas, inscribed lower left: *E L Henry. NA 1911,* 29 ¼ x 60 ½ inches. The Warner Collection of Gulf States Paper Corporation.

Figure 55 **Wallace Nutting** (1861–1941) *Fan-back Armchair,* after 1917, hardwoods, pine, paper label affixed to underside of seat: *Wallace Nutting Trade Mark,* 46 ¾ x 26 ½ x 23 inches. Virginia Museum of Fine Arts, Bequest of John C. and Florence S. Goddin, by exchange.

Figure 56 **Daniel Chester French** (1850–1931) *"George Washington," A Bronze Equestrian Group,* 1900, bronze, inscribed on base lower left: *D C French/ E C Potter/ Paris,* 1900, 31 ¾ inches high. The Warner Collection of Gulf States Paper Corporation.

Edward Hopper
Dawn Before Gettysburg

Still they are brooding in their fanes afar;
And now they stir the oak leaves with their breath,
Saying there is no life, neither is death,
Nor Victors, nor defeated, nor fame, nor war . . .

— Edgar Lee Masters, "Gettysburg," 1935

In the mid 1930s, Edward Hopper revived a boyhood fascination with the Civil War to produce a handful of images depicting the Battle of Gettysburg. At this point in his career, he had already achieved acclaim for his characteristic paintings of isolated individuals within the urban environment—such as *House at Dusk* (Fig. 57), with its glimpse of a woman through an apartment window. Hopper's brief foray into military history resulted in the unusual and compelling *Dawn Before Gettysburg* (Pl. 29).

Hopper brings the specter of warfare literally into the American backyard. At the break of dawn, a Federal regiment awaits orders to take its place at the battlefront south of the small Pennsylvania town. An alert sergeant keeps watch as his men sit, shoulder to shoulder. Their uniformed figures—whose numbers stretch indefinitely to the left beyond the picture plane—echo the enforced regularity of the slats in the picket fence behind them. However, their slumped bodies and teetering bayonets show

little of the barrier's rigid solidity. Each soldier, with averted face and downcast eyes, copes silently with his own fatigue, boredom, and rising fear in anticipation of the day's combat. Hopper does not indicate which morning of the deadly three-day battle the soldiers face, but the white fence offers a visual pun on the famous, catastrophic assault by Pickett's Confederate division on the final afternoon. The Federal army's decimation of the mile-wide column of Southern infantry gave the North victory in the battle and, ultimately, an advantageous turning point in the war.

In the seventy years between the Battle of Gettysburg and Hopper's portrayal, American soldiers were involved in several more conflicts in North America and abroad. Their endeavors were recorded by artists with varying degrees of heroic romanticism. New Jersey artist Gilbert Gaul specialized in military imagery in the decades spanning the turn of the century. Depicting scenes from the Civil War, Spanish American War, and the Indian Wars, his paintings were translated into illustrations for such popular magazines as *Century, Harper's,* and *Scribner's.* Gaul's *Exchange of Prisoners* (Fig. 58) pictures a lull in hostilities in the Indian Wars during which beleaguered soldiers negotiate—through a Native American interpreter—for a trade of captured men. Backed against the fenced barricade of their fort, the troops look outward with intense concentration.

Hopper's assemblage of quiet, enigmatic soldiers avoids the narrative drama of Gaul's battle scene. American taste for military subjects had diminished by the early 1930s. His audience would have had clear memory of the carnage of World War I—the "war to end all wars." Isolationist and intensely focused on the economic battles of the Great Depression, thousands of unemployed men enlisted in newly formed Federal Works Projects. Unaware of the war to come, uniformed "soil soldiers" of the Civilian Conservation Corps waited for orders in long lines along the back lanes of America.

ELO

Plate 29 **Edward Hopper** (1882–1967)
Dawn Before Gettysburg, 1934, oil on canvas, inscribed lower right: *E. HOPPER,* 15 x 20 inches. The Warner Collection of Gulf States Paper Corporation.

Figure 57 **Edward Hopper** (1882–1967)
House at Dusk, 1935, oil on canvas, inscribed lower left: *E. HOPPER,* 36 ¼ x 50 inches. Virginia Museum of Fine Arts Purchase, The John Barton Payne Fund.

Figure 58 **Gilbert Gaul** (1855–1919)
Exchange of Prisoners, undated, oil on canvas, inscribed lower left: *Gilbert Gaul,* 34 x 44 inches. The Warner Collection of Gulf States Paper Corporation.

Jamie Wyeth
Dome Room

The whole commerce between master and slave is a perpetual exercise of the most boisterous passions, the most unremitting despotism on the one part, and degrading submissions on the other.

—Thomas Jefferson, *Notes on the State of Virginia*, 1785

When Jamie Wyeth traveled to Monticello in 1995, he followed in the footsteps of many portraitists who journeyed to the mountaintop home of Thomas Jefferson to paint the well-known statesman, scholar, and author. Unlike such long-ago predecessors as Charles Peale Polk, for whom Jefferson sat in 1799 (Fig. 59), Wyeth constructed an imaginary likeness of the third American president (Pl. 30). Within the empty space of Monticello's dome room, he pictured an absorbed young Jefferson gazing out at his beloved estate. Turned away with hands behind his back, Jefferson fails to notice the glance of a young African American woman at the door. A silent tension seems to fill the distance between master and slave.

Wyeth's visit to Monticello rekindled his lifelong fascination with Thomas Jefferson. Twenty years earlier, the third-generation painter from a famous dynasty of American artists produced a series of portraits of Jefferson for *Time* magazine's Bicentennial issue. In this later image, however, the artist refers directly to the central paradox of Jefferson's life. The author of the Declaration of Independence, who urged that all men were created equal, was at the same time a slave owner. Throughout his lifetime, about two hundred enslaved farm laborers, artisans, and household workers maintained his various properties.

Steeped in the Enlightenment theory of the late eighteenth century, which championed the democratic impulses of ancient civilizations, Jefferson embraced "everything rational in moral philosophy which Greece and Rome have left us." Neoclassical taste in architecture and the fine and decorative arts arrived in America just at the time the Virginian and other colonial leaders struggled to form a new republican government. Searching for exemplars of ideal order and beauty, Jefferson found inspiration in ancient motifs—such as the dome—as he built and furnished Monticello. Even the swags and tassels of the drapes he designed for his parlor echo such classical ornament as the chased band around a teapot made by silversmith and patriot, Paul Revere (Fig. 60).

Regularity, order, and reason also imposed rules on social behavior in the new nation. A sense of decorum might have prevented Jefferson from answering the public accusation that he had fathered several children with his slave, Sally Hemings. The allegation, published first by an embittered political associate, survived over time until it reemerged in recent decades as the focus of books and film. While Jamie Wyeth does not identify the slave figure as Hemings, his painting hints at the unresolved controversy. Wyeth, who came of age in the Vietnam era, began his career producing on-the-spot drawings at the U.S. Supreme Court during Watergate pretrial impeachment hearings. Seasoned by a culture that questions its leaders and institutions, the artist brings a postmodern ambivalence to his rendering of a complex, enigmatic Jefferson. ELO

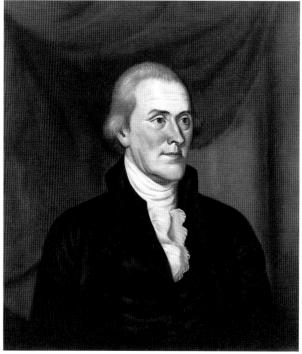

Plate 30 **Jamie Wyeth** (b. 1946) *Dome Room,* 1995, oil on canvas, inscribed lower left: *J. Wyeth,* 36 x 30 inches. The Warner Collection of Gulf States Paper Corporation. © 1995 Jamie Wyeth.

Figure 59 **Charles Peale Polk** (1767-1822) *Thomas Jefferson,* 1799, oil on canvas, unsigned, 26 ½ x 23 ⅛ inches. The Warner Collection of Gulf States Paper Corporation.

Figure 60 **Paul Revere II** (1735–1818) *Teapot and Stand,* circa 1790–95, silver, wooden handle, marked on bottom of teapot and stand: *Revere,* 7 ¼ inches high. Virginia Museum of Fine Arts, Gift of Daniel D., Lilburn T., and Edmund M. Talley in memory of their mother, Anne Myers Talley, and Purchase, The Arthur and Margaret Glasgow Fund.

Index

Italicized numbers refer to pages with illustrations.

Artists

Objects